SEEKING THE SPIRITUAL

The Paintings of Marsden Hartley

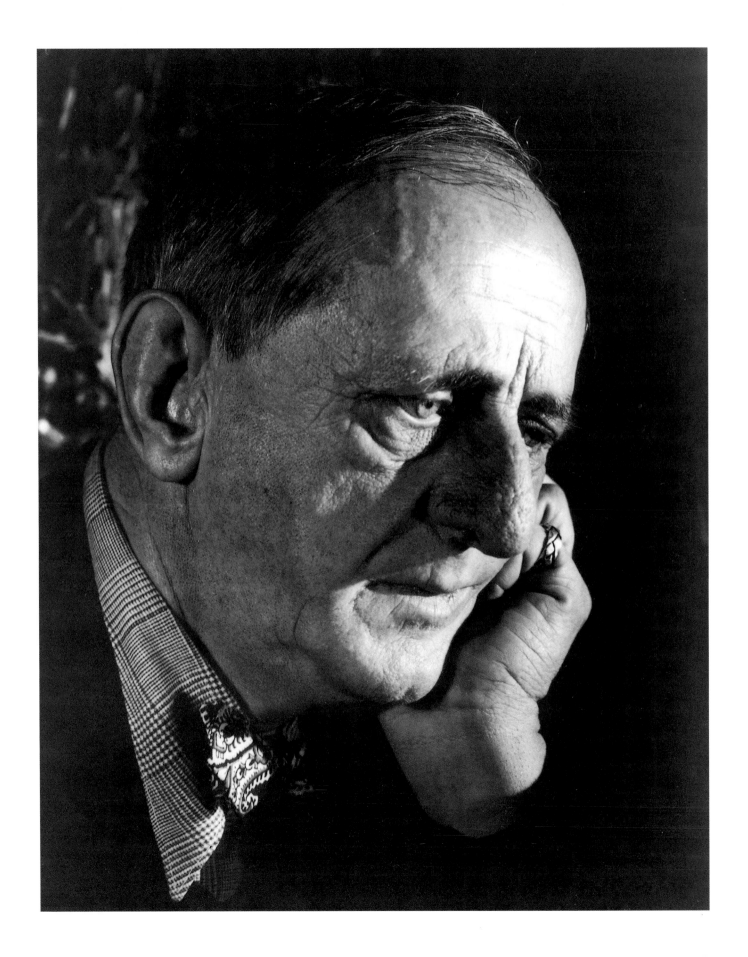

SEEKING THE SPIRITUAL
The Paintings of Marsden Hartley

Townsend Ludington

Curated by
Barbara Matilsky
&
Lisa Skrabek

PUBLISHED IN ASSOCIATION WITH
THE ACKLAND ART MUSEUM,
UNIVERSITY OF NORTH CAROLINA AT CHAPEL HILL,
& BABCOCK GALLERIES, NEW YORK

CORNELL UNIVERSITY PRESS
ITHACA AND LONDON

This book is published in connection with the exhibition
"Seeking the Spiritual: The Paintings of Marsden Hartley,"
organized by the Ackland Art Museum,
University of North Carolina at Chapel Hill,
and Babcock Galleries, New York.

For information, address
Cornell University Press
Sage House, 512 East State Street
Ithaca, NY 14850

First published 1998 by Cornell University Press.

Produced by
Chameleon Books, Inc.
31 Smith Road
Chesterfield, MA 01012

Production director/designer: Arnold Skolnick
Editor: Lisa Skrabek
Editorial assistant: Laura J. MacKay
Copy editor: Jamie Nan Thaman
Printed and bound by O. G. Printing Productions, Ltd., Hong Kong

Cloth printing 10 9 8 7 6 5 4 3 2 1

Librarians: Library of Congress Cataloging-in-Publication Data are available.

ISBN: 0-8014-3553-6

(frontispiece)

Alfredo Valente
Marsden Hartley, 1942
Gelatin silverprint, 13 1/2 x 10 1/2 inches
Private collection, courtesy Babcock Galleries, New York

IN HONOR OF MICHAEL ST. CLAIR

Who for more than sixty years has
encouraged the admiration, exhibition,
study, and acquisition of works
by Marsden Hartley.

LENDERS TO THE EXHIBITION

Babcock Galleries
Mr. Gary T. Capen
Hirschl and Adler Galleries
Dr. and Mrs. Henry Kaufman
Joan Michelman Ltd.
Barbara B. Millhouse
North Carolina Museum of Art
Philadelphia Museum of Art
Private Collectors
Harvey and Françoise Rambach
Rose Art Museum, Brandeis University
The Saint Louis Art Museum
Santa Barbara Museum of Art
Schrag Family Collection
The Vault Art Trust, Boston
Washington University Gallery of Art, St. Louis

ACKNOWLEDGMENTS

Several years ago Professor Townsend Ludington of the University of North Carolina at Chapel Hill authored the fine and exceedingly well-received *Marsden Hartley: The Biography of an American Artist* (Boston: Little, Brown and Company, 1992). Subsequently, Ludington has continued his provocative consideration of Hartley's life and work. *Seeking the Spiritual: The Paintings of Marsden Hartley* amplifies ideas he developed earlier, and explores their impact and manifestation in specific works from each period of Hartley's life. We are pleased to bring together the Ackland Art Museum, University of North Carolina at Chapel Hill, and Babcock Galleries, New York, to present this publication and exhibition of Hartley's work.

We thank the many lenders who have so graciously participated by sharing masterworks from their collections. We acknowledge the considerable contributions of Barbara Matilsky, Curator of Exhibitions at the Ackland Art Museum, and Lisa Skrabek, Assistant Director of Babcock Galleries, in curating the exhibition. Thanks also goes to Anne Douglas, Registrar, Ackland Art Museum, for arranging the loans of Hartley's paintings and to Geoffrey Clements for skillfully photographing the majority of the works. Our goal was not only to organize a fine exhibition but also to produce a lasting publication that would provide wider access to Hartley's work. This was genially and beautifully accomplished through the efforts of Chameleon Books and Cornell University Press. Most of all, we acknowledge the fine and living achievement of Marsden Hartley.

Gerald D. Bolas, Director
ACKLAND ART MUSEUM
UNIVERSITY OF NORTH CAROLINA AT CHAPEL HILL

John Driscoll, Ph.D., Director
BABCOCK GALLERIES, NEW YORK

L ATE IN HIS LIFE THE PAINTER MARSDEN HARTLEY (1877–1943) composed a short poem that summed up his sense of himself and his relationship to whatever god-force might exist. Entitled "To the Nameless One," it reads:

> You, who have power over
> everything obscure
> Listen—come over here; sit by
> my side
> and let me say the things I want
> to say—
> I want nothing in the way of artificial
> heavens—
> The earth is all I know of wonder.
> I lived and was nurtured in the
> magic of dreams
> bright flames of spirit laughter
> around all my seething frame. [1]

Fig. 1
LANDSCAPE NO. 20, RESURRECTION, 1909
Oil on academy board, 13 1/2 x 11 1/2 inches
Private collection, courtesy Vanderwoude
Tananbaum Gallery, New York

It is common knowledge that throughout his career Hartley painted land and seascapes—*Landscape No. 20, Resurrection* (Fig. 1); *Waterfall* (Fig. 2); *Autumn Impressional* (c. 1906); *New Mexico Landscape* (1919); *New Mexico Recollections No. 11* (1922); *Smelt Brook Falls* (1937); *End of Storm, Vinalhaven, Maine* (1937–38)—in which he tried to convey his sense of the wonder of earth, at the same time attempting to articulate his awareness of the spiritual that came to him in the "magic of dreams" and was filtered through his abundant imagination. He struggled to comprehend and express creatively the tensions he perceived between the self and the spiritual world, between imagination, intellect, and nature as he understood them. Eventually he found settings that allowed him to immerse himself in what he called "the mysticism of nature." In these settings, influenced by all that he had read, he was compelled to create art from adversity and from the harshness and stolidness he felt to be inherent in the world. Forged from disparate elements, his work embodied modernism, making Hartley a significant representative of that major moment/movement in American culture. Like Wallace Stevens, Hartley strove to express "not ideas about the thing but the thing itself." In that concept he found meaning, even a kind of faith. The acts of reading, writing, and painting gave significance to the modern world as he saw it.

pls 1, 8
pls 9, 23,
pl 24

He thought of himself as a writer as well as a painter, and during the course of his life, he composed literally hundreds of poems and essays. The vast majority were never published, but a fair number appeared in periodical and book form. Clearly, writing was important to him; living

Fig. 2
WATERFALL, 1909
Oil on academy board, 12 x 12 inches
Frederick R. Weisman Art Museum,
University of Minnesota, Minneapolis
Bequest of Hudson Walker from the Ione and
Hudson Walker Collection

alone and often lonely, he found a sort of companionship in the voice on the page that spoke to him as well as to others when he wrote letters or when his pieces were published. His writing usually resulted from what he had been reading; it was one way for him to work out the ideas and emotions he had absorbed, which would eventually take visual form in paintings and drawings. He was a remarkably learned man; self-taught for the most part, he read voraciously and from what he had imbibed, developed the ideas that informed his art. His essays are more often than not appreciations; his poems may reflect something of the styles of painting most on his mind at any given moment, but they are not analyses of technique so much as they are indications of the ideas—call them elements of a philosophy—that were affecting him as he wrote.

Hartley, a product of Maine if ever there was one, had no formal education—other than in the field of art—beyond the age of sixteen. From early on he felt at odds with life in the small industrial city of Lewiston, and reading took him out of himself. In his early twenties he became enamored of the transcendentalists: Emerson, Thoreau, and soon after Whitman were his gods, even as he struggled with a severe case of New England puritanism, which ran counter to his philosophic bent as well as to his homosexuality. By 1900 he had located for long winters in New York, the closest place to a haven he could find in America, and in 1909 he met the pioneering proponent of modern art in the United States, Alfred Stieglitz, establishing what would become one of the most significant—and complex—relationships of his life. At Stieglitz's 291 Gallery Hartley first made contact with a small group of American modernists—artists such as Max Weber and Alfred Maurer—with whom he quickly identified. He also got his first glimpse of the art of painters such as Matisse, Picasso, and Cézanne, whose work had an immediate and powerful impact on him.

Soon nothing could stop him from traveling to Europe. With great help from Stieglitz, he went in 1912, living first in Paris and then, at the turn of the year, visiting Germany. Hartley returned to Germany in the spring of 1913 and remained with only brief breaks until the increasingly difficult circumstances of living during World War I as a foreigner in his beloved Berlin forced him to return to the United States. His European experiences caused him to read broadly: in 1912 he delved into Wassily Kandinsky's *On the Spiritual in Art,* the works of Henri Bergson, and translations of the mystics Boehme, Eckhart, Tauler, Suso, and Ruysbroeck, to name but several of the writers whose ideas were helping to shape his thinking.

To go step by step through Hartley's reading and the writing that resulted from it would be a major exercise. Suffice it to say that the pattern

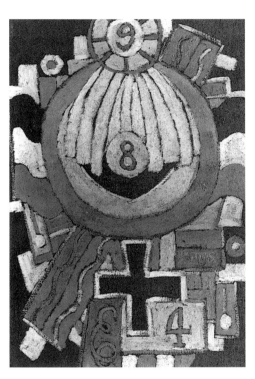

Fig. 3
PORTRAIT, c. 1914–15
Oil on canvas, 32 1/4 x 21 1/2 inches
Frederick R. Weisman Art Museum,
University of Minnesota, Minneapolis
Bequest of Hudson Walker from the Ione and
Hudson Walker Collection

for the rest of his life was established: he read widely and intensely among writers of all sorts, and from this, as from the artists he admired, came the ideas that pervade his work, both visual and written. Almost instantly after reading Kandinsky and the mystics in 1912 and 1913, for example, his paintings took remarkable new directions, as with *Musical Theme* *pls 2, 3* *(Oriental Symphony)* (1912–13) and *Indian Fantasy* (1914). Several years later, when he was reacting against the imagination and attempting to don intellect as a kind of defense against the painful emotions he had suffered during World War I in Germany, his poetry took on a precious brittleness. "Upon the étagère of her quaint mind she was fond / of arranging the bijouteries of her queer fancies / Like gems sheathed with glass"[2] begins a poem that appeared in the *Little Review* for December 1918. His painting, likewise, turned away from the passion that had been expressed in major works such as those of his famous German Officer series—painted gatherings of military insignia that celebrated the young men he loved as well as the pomp and order of the German army (compare, for example, *pl 5* *Movement No. 3, Provincetown* [1915–17] with *Portrait* [Fig. 3] and *pl 4* *The Iron Cross* [1915])—or that would be expressed in the powerful, Ryderesque land- and seascapes and primitive portraits—*Adelard the Drowned, Master of the Phantom* (Fig. 4); *Northern Seascape, off the Banks* (Fig. 5)—that he painted during the last twelve years of his life, after returning to the United States in 1930 from an extended second trip to Europe. In these "hot" images—as compared to those that are cubistically "cool"—the elements of "the thing itself" are celebrated, noteworthily by the dense texture of the paint and clear, sharply delineated colors.

The years 1929–1930 were pivotal for him. The immediate cause of his return stateside was the almost absolute failure of a major show of his paintings at Stieglitz's Intimate Gallery in January 1929, a failure due primarily to the fact that the critics—and even Stieglitz—did not appreciate the landscapes Hartley had done in Provence—*Landscape, Vence* (Fig. 6); *pl 12* *Landscape No. 29, Vence* (c. 1926). Utterly dismayed, at some point he penned a poem that captured his sense of isolation and also an inner sense of self that would have surprised those who saw only a shy, introverted, often hypochondriacal man. "The eagle wants no friends," he wrote,

> employs his thoughts to other ends—
> he has his circles to inscribe
> twelve thousand feet from where
> the fishes comb the sea,
> he finds his solace in unscathed
> immensity,

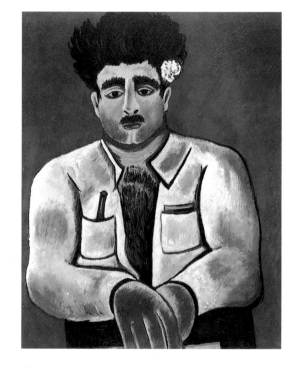

Fig. 4
ADELARD THE DROWNED, MASTER OF THE PHANTOM, c. 1938–39
Oil on academy board, 28 x 22 inches
Frederick R. Weisman Art Museum,
University of Minnesota, Minneapolis
Bequest of Hudson Walker from the Ione and Hudson Walker Collection

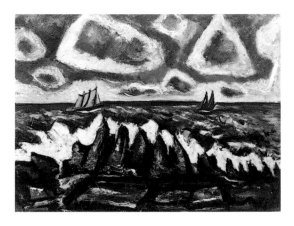

Fig. 5
NORTHERN SEASCAPE, OFF THE BANKS, 1936
Oil on cardboard, 18 3/16 x 24 inches
Milwaukee Art Museum Collection
Bequest of Max E. Friedman

where eagles think, there is no need
of being lonesome—
In isolation
is a deep revealing sense
of home.[3]

Isolation had always been a sort of home for him; now he vowed to take advantage of it to find order and some kind of peace. This would require returning to America, another home that had not in his estimation ever treated him particularly kindly.

Before he departed from France he spent the summer and fall in Provence, not painting landscapes, but restricting his activities to the painting of still lifes—*Still Life with Red Drape* (1929), *Still Life (with Garlic)* (1929)—and to reading and writing. His aim was to develop a style of existence that would permit him to get a new sense of self, which involved freeing himself of egocentricity. "How hard it is to escape the feeling that anything is important—that oneself is important—that expression is important," he wrote to a friend during the summer. He observed, "The trouble with artists is…they are so willfully oblique and trust implicitly in their ego-eccentricity to get them through." In Paris the previous winter he had gotten a stomachful of their self-centeredness, to the point where he believed that the expression of self was useless. In an effort to comprehend all this, he began reading philosophers and mystics such as Santayana, Miguel Unamuno, and Sainte Thérèse of Lisieux, "the 23 yr. old girl who died and literally went to heaven," he noted.[4]

pls 13, 14

As the summer progressed he read more of Santayana, whose *Platonism and the Spiritual Life* particularly impressed him. What the philosopher had to say about spirituality helped Hartley tremendously as he struggled with physical pain and many rebuffs—some imagined—to his ego. Hartley was trying to balance the material and the spiritual and to understand how intelligence could absorb nature, or rather one's sense of the natural world, which is all a person could know and from which came his art. "The difference between the life of the spirit and that of the flesh is itself a spiritual difference," Santayana wrote, and continued:

> the two are not to be divided materially or in their occasions and themes so much as in the quality of their attention: the one is anxiety, inquiry, desire, and fear; the other is intuitive possession. The spirit is not a tale-bearer having a mock world of its own to substitute for the humble circumstances of this life; it is only the faculty—the disenchanting and re-enchanting faculty—of seeing this world in its simple truth. [5]

Fig. 6
LANDSCAPE, VENCE, 1925–26
Oil on canvas, 25 1/2 x 31 3/4 inches
Frederick R. Weisman Art Museum,
University of Minnesota, Minneapolis
Bequest of Hudson Walker from the Ione and
Hudson Walker Collection

He observed that "pure spiritual life cannot be something compen-

satory, a consolation for having missed more solid satisfactions: it should be rather the flower of all satisfactions, in which satisfaction becomes free from care, selfless, wholly actual and, in that inward sense, eternal. Spiritual life is simple and direct, but it is intellectual."[6] Hartley had struggled with his lack of faith in what Santayana referred to as a "necessary and all-comprehensive being." But the philosopher wrote that there was no such entity "except the realm of essence,"[7] which for Hartley was the world he knew and tried to express through his artistic renderings of it.

"Spirit is awareness, intelligence, recollection. It requires no dogmas, as does animal faith or the art of living,"[8] Santayana asserted, offering reassurance to Hartley, who doubted the validity of any formal doctrine of faith. "The attachment of spiritual minds to some particular system of cosmology, Platonic, Christian, Indian, or other," declared Santayana, "is...a historical accident—a more or less happy means of expression, but a treacherous article of faith."[9] He noted that the Nirvana of Indian philosophy "annihilates personality, desire, and temporal existence," but that "far from being nothing Nirvana embraces the whole realm of essence—pure Being in its infinite implications."[10]

After reading *Platonism and the Spiritual Life*, Hartley asked a friend to send him others of the philosopher's essays. "Santayana seems made for the artist's requirements," he announced, and in November, in a letter that was a kind of retrospection of his time in Provence, written just before he left for America, he praised a line of Santayana's about "distinguish[ing] the edge of truth from the might of the imagination." This, Hartley thought, was "one of the finest appreciations" he had ever read. Santayana's work had helped him immensely to come closer to being able to hold to "the edge of truth" by separating himself from his self-centered, if powerful, imagination: "I value myself less & less....There are ideas far more important than oneself," he declared.[11]

He believed he had risen above "the worst defects of the [artistic] psychology" and was working toward a calm that came through accepting life as it was. "After all what is visible is all we can seem to know and the rest is left to romanticism & to ecstasy," he observed. He delighted in the mystics because of "their sense of certainty," though he himself was not specifically religious. What they wrote was "at least a romantic incursion into the souls of other beings" who had "found the living truth" for themselves—or so he remarked at about that time in an essay on Sainte Thérèse, whose mystical experience spoke "for the perfect sense of the relation of artistry to the religious function."[12]

In Hartley's view, reading the mystics enabled him to draw off his romantic imagination from what he perceived, allowing him to render the "edge of truth" about it without succumbing to the demands of "ego-

eccentricity." Two years later, in 1931, he would move closer to religious belief and to an acceptance of the idea that the personal, if it was not merely self-centered, could become a valid part of "the edge of truth."

As he neared the time of his departure for the United States, he willed himself to be pleased, even declaring that he had "never once stepped off my own soil because you don't transpose a New Englander."[13] Nevertheless, it was a wrench to leave Provence. If he were to make a pilgrimage, he wrote Stieglitz, it would be to there, and during the summer and fall of 1929 he wrote poems about that part of France, their tone suggesting his calm and his love for it, where when summer was done the mistral blew the season out over the Mediterranean and transformed the land. With the advent of autumn, no more did "the perdreaux skim above / the pungent gorse, / the newts and lizards seek / a lingering warmth of wall, / the junipers a multiplying blue, / [or] the cigales sing." In the hills around Aix solitude could be beautiful, and one could at least be "within" oneself and cease to be like "perishable blooms / of fruits and leaves— / the thing upon the surface / giving only shine / from other superficial things"[14]— which, variously shaped, filled up the mold of existence but were less than all it was. To be "within" was to gain a sense of essences, of the spiritual, and of the profundity of forms and objects. Reading, writing, and the calm of Provence had brought Hartley halfway toward finding the balance between self and other that would enable him to paint as he did during the last twelve years of his life.

Back in the United States, he tried painting in the mountains of New Hampshire during the summer of 1930, but they lacked the dramatic shapes that moved him as had Mont Saint-Victoire, and his efforts, while of some interest, were not notable (see *Mountain No. 14* [Fig. 7]). Still, he held to his wish to find a balance in life. He recalled Gloucester, which had caught his fancy in 1920. In the summer of 1931 he returned there and found a situation as satisfying as the New Hampshire mountains had been disappointing. The result was an outpouring of painting and poetry that marked the beginning of his greatest sustained period of creativity.

At the center of it in 1931 was Dogtown, an area in the low hills behind the port. In its landscape he found the nexus of all he felt and read and wrote about spiritualism. His Dogtown paintings became modernist expressions of "the thing itself," the mysterious something he sought to know, which was as close to revelation as he could reach. "I go every day to 'Dogtown' which is one of the most ancient settlements in the U.S.," he wrote a friend in mid-July, and "a very strange stretch of landscape it is." He described it as "full of magnificent boulders driven & left there by the glacial pressure ages ago."[15] Almost no one went there, so "a sense of eeriness pervades all the place...and the white ghosts of those huge boulders—

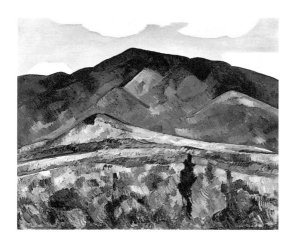

Fig. 7
MOUNTAIN NO. 14, 1930
Oil on canvas, 40 1/2 x 33 1/2 inches
Private collection
Courtesy of the Portland Museum of Art,
Portland, Maine
Photo by Benjamin Magro

mostly granite—stand like sentinels guarding nothing but space," he wrote in a memoir. "Sea gulls fly over it on their way from the marshes to the sea. Otherwise the place is forsaken and majestically lovely as if nature had at last formed one spot where she can live for herself alone."[16]

Stimulated by Dogtown, he read widely: memoirs, the short stories of Sarah Orne Jewett, T. S. Eliot's poetry and that of Gerard Manley Hopkins, as well as his by then usual quotient of mystics and philosophers. Jewett in particular helped him to set his own New England experiences in the context of nature. Her poignant tales about the harsh and isolated life in Maine moved him deeply; he began to see more and more clearly that the land and its people could be the subject of art as well as of scorn. And Eliot's poem "Ash Wednesday," published in 1930, struck a central chord in him. He understood the other poet's search for meaning in faith:

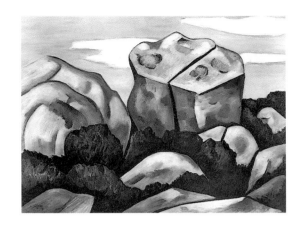

Fig. 8
IN THE MORAINE, DOGTOWN COMMON,
CAPE ANN, 1931
Oil on academy board, 17 3/8 x 23 1/16 inches
Georgia Museum of Art, The University of Georgia
University purchase, 1969
Photo by Dan McClure

> This is the time of tension between dying and birth
> The place of solitude where three dreams cross
> Between blue rocks

So wrote Eliot in the last section of the poem, which Hartley may have read as he sat among the boulders in Dogtown. Soon he would pick up on other lines from the section and write them on the back of one of his memory paintings of Dogtown, which he titled *In the Moraine, Dogtown Common, Cape Ann* (Fig. 8):

> Teach us to care and not to care
> Teach us to sit still
> [Even] among these rocks

"I paint rocks & rocks only," he wrote a friend, referring to his painting and Eliot's lines on the back. The poem served him "as a kind of biblical motto," he observed, "for it is what I am trying to practice in my life just now. To care magnificently—& equally not to care—in the same [manner]—Precept enough don't you think for one [tame] life."[17]

Dogtown and the poetry of others inspired him to write as well as paint. On the back of another painting done that fall, *Flaming Pool, Dogtown* (Fig. 9), he inscribed a poem that he called "Beethoven (in Dogtown)":

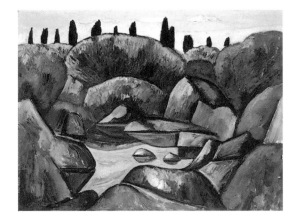

Fig. 9
FLAMING POOL, DOGTOWN, 1931
Oil on academy board, 18 x 24 inches
Yale Collection of American Literature
Beinecke Rare Book and Manuscript Library
Yale University, New Haven, Connecticut

> Deep chested trills arise—
> from organ pipes of juniper
> Oboe's throat expands—mezzo cries
> of blueberry and sage and ferns prefer
> to die among the rocks, nobly perish
> mire of torrid green—

14

Summer's strident blades of damascene
hot tone or here is garish
the vox human swells and dwells
Persistently mid nuances of lapis grey
So much more wonderful this way
than summer in a trance
of chlorophyll or other circumstance [18]

"I am trying to return to the earlier conditions of my inner life—and take out of experience as it has come to me in the intervening years that which has enriched it—and make something of it more than just intellectual diversion," he explained to an artist friend. What he was trying to do was "the equivalent of what the religious minded do when they enter a monastery or a convent and give up all the strain and ugliness of Life itself." Not that he would actually retire from life, but he wanted to get some distance between himself and it—to learn, as Eliot wrote, "to care and not to care."[19] Eliot found spirituality in the Anglican Church; Hartley sought it in Being—essence, as Santayana noted, devoid of "personality, desire, and temporal existence." As Hartley came to accept Santayana's assertion that existence is excluded from "the whole realm of essence—pure Being in its infinite implications," he heeded less the vicissitudes of a frequently troubled life and worked to express the spirituality, the essence, he sensed in pure forms of nature, be they the birds and fish he found along the coasts of Maine and Nova Scotia, the people—living and dead—who became his heroes, the mountains of Bavaria and later Maine, or the stolid boulders and ravines of Dogtown (*Mountains in Stone, Dogtown* [1931]). pl 15

Things were coming together for him under the influence of Dogtown and the reading that it had inspired. He told a friend that he wanted to dedicate a book of poetry to her, and the poems were "to have the emotions beneath the pattern as sharply as possible." It was a matter of reconstruction, he claimed elsewhere. "I have laid new principles of life for myself and have given up old forms and concepts." He hoped to rid himself of "all aesthetic baggage [in favor of] something richer and deeper." He believed that this would show in his new paintings; he wanted them to be "painted sculpture & no ordinary painting and I think they mostly are. I feel as if I am casting off a wearisome chrysalis & hope to emerge a clearer and more logical and consequent being," he announced, noting that he had "read deeply this summer—felt & thought deeply—& written deeply."[20]

For Hartley, nothing conveyed the impermanency of man more than the Whale's Jaw, an outcropping of rock at the north end of Dogtown Common (*The Whale's Jaw* [Fig. 10]). Split apart thousands of years

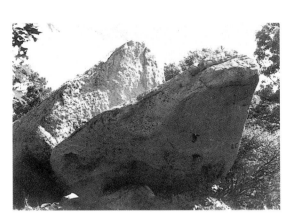

Fig. 10
THE WHALE'S JAW, 1990
Dogtown Common, Gloucester
Photo by Townsend Ludington

before, the two parts of the boulder looked like the head of a whale as it broke from the water. The rock loomed over anyone who approached it, its shape symbolic of nature's power and age. Hartley knew his Melville; the Whale's Jaw was a keen reminder of Moby Dick's endurance—of Ahab's finitude and futile egotism. The feebleness of man's assertions of self seemed especially poignant to Hartley when he came upon workers who at the behest of a local industrialist, Roger Babson, were chipping away at boulders in the Common in order to carve out words and phrases such as "Integrity," "Study," and "If Work Stops Values Decay." Hartley knew his Shelley also, and these carvings, as well as the initials sculpted into the Whale's Jaw, dating back to 1891, reminded him of Ozymandias, the King of Kings, whose boastful words remained sculpted in the ruins of an immense statue long after his voice had been stilled.

"It was a fine example of intuitive truth the coming here," Hartley wrote to Stieglitz as the fall wore on. He had done many things inwardly for himself, he knew, and had written enough poetry to fill a volume, all the while steeping himself in literature, especially about Mexico, where he was soon to go. He singled out a book, *Mexican Maze,* by Carleton Beals—long a resident of Mexico and writer about the country—which was full of "spiritual documentation" that interested him deeply in his present mood[21]

When Hartley arrived in Mexico in March 1932, it took his breath away, although soon he would become disenchanted with its Latin spirit. The land and the people had an effect on him that he had not expected. Dogtown had inspired him to paint directly from the landscape; Mexico did not, as he felt too removed from its culture. But he read deeply in the mystics and was brought closer to a sense of the "thing itself" that lay beneath surfaces—call it God, soul, essence, or what you will. In Mexico he painted symbolically, out of his readings, as in the painting *Morgenrot* *pl 17* (1932), where he represented the German mystic Jakob Boehme's belief that in the seventh realm of divine corporeality the word of God is materialized. Later, in what was to him the more amicable atmosphere of Austria and then Nova Scotia and the United States, he could paint with a new serenity—a real sense of spirituality—taking as his subject mountains, birds, fish, islands, or even the human figure, which had been notably absent from almost all of his earlier work.

The Mexican spirit dominated him for as long as he remained in the country. "It was a place that devitalized my energies," he wrote in a memoir after he left. He found "all the colors and the forms...at variance with each other—nothing becomes precise—neither form, design, or colour." Because the Spaniards had invaded the country, it had never had the "privilege of completing its mystical significance through its own

people," he believed. Indians, Spaniards, and mixed breeds made for what he termed a "novel, powerful, dramatic Mexico—full of irrelevant bravadoes, extravagant notions of power, animalistic impulses ruling everything—to hate, to kill, [is] any man's diversion and bothers no one—take what you want, kill whatever stands in the way."[22]

His experience with Mexico was bittersweet, but it stimulated him, and he wrote about it repeatedly. In a piece entitled "Mexican Vignette," he remarked on "the magic of nature," something that he believed an artist could not learn about but must somehow intuit. The magic—"the mystic sense of earth"—existed "beneath the surface of what the eye sees," he claimed, noting that Cézanne had striven for it, for that thing that lay between the artist and the object. "It is not a deity but a presence," Hartley asserted, no doubt recalling Santayana while hinting at his difficulty with Mexico by adding that "primitive peoples made everything into a deity because everything natural contained the presence of the supernatural." In order to represent nature properly, the artist needed to find out what that was. Its essence was in mountains, lakes, rivers, and seas. It was what religious cults and mythologies were made from; in Mexico, he observed, "among the Aztec ruins, you get a terrific sense of the belief in the supernatural.... Everyone here in Mexico is an earth-cultist."[23]

In such a context, religion became a totally personal, physical matter, Hartley believed, and in an essay entitled "The Bleeding Christs of Mexico," he wrote about "the significance of blood to the Spanish soul and mind" and how that significance was reflected in Mexican churches. Blood and suffering were important to the Spanish nature, he thought, and again and again in the ornately decorated Mexican churches one could discover representations of them. The churches, such as a small chapel in the village of Acatapec, were ablaze with color, from jewels and glazes of azure, lapis, primrose, and pomegranate and from layers of the richest gold leaf. "Gold on gold on gold," he marveled, "no matter where you look, no escape from gold, all the varieties of monochrome painting joined with it to give it variety and still more splendour, fabrics of the richest sort, the illusion magnificently achieved of the visit of the holy spirit among the yearning."[24]

Amid what he called "this strange life and climate," he lived out his year in Mexico, reading and painting.[25] When he moved away from Mexico City to Cuernavaca he became friendly with a couple who had a large collection of books on mysticism. Almost immediately he delved deeply into these works. The lyrics of Richard Rolle excited him: they "fairly burn with fervor," he told another friend, and his only regret was that he could not "join them in belief" (see *The Transference of Richard*

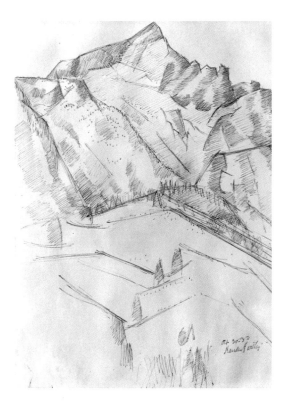

Fig. 11
WAXENSTEIN DRAWING, 1933
Pen and ink drawing
Private collection
Courtesy Townsend Ludington

Rolle [1932]). Rolle was especially attractive to him because he was not "hysterical or neurotic." Hartley noted that "the mystical contact with life itself is anyone's privilege and one doesn't have to be a Christian to feel the glow and the glory of being, and life should be that."[26] Soon he had read much of two volumes of Paracelsus's work and had run through the two volumes of *Isis Unveiled*, a study of mysticism by Helena Blavatsky, one of the founders of Theosophy. Hartley thought the mystics to be "the great writers of romance because the highest love is the basis of all their themes." Rolle, for instance, would have had nothing to do with theorists or dogmatists, he was confident, because the one truth for him "was the love of Christ."

pl 16

By this time Hartley had begun what he termed "two pictures of mystical import." This was "the first time I have come so close to these things [mystical matters]," he believed, and he hoped that it would create new interest in his work. There was little point in copying "the common facts of life," he asserted. Cubism, "hollow as it was and is," had represented a great release from fact, as had for Hartley the numerous canvases based on mysticism that he had done in 1912–1915. The two new pictures were *The Heimkehr* (or *"Return,"* which he later changed to *"Transference"*) *of Richard Rolle* and the *Breath of Iliaster*. He had discarded all blacks and browns and returned to primary colors, so that at least his pictures would be "gayer and more exciting to the eyes—if not to the average mind."[27]

As his stay in Mexico neared its end, he could write in one mood that "it has been a rich year intellectually and spiritually,"[28] but in another he damned it. He had had "too many difficulties," he told an artist friend, Donald Greason. The place was "too picturesque—all like cigar box labels of 1880," and it wore out the eye and dulled the mind. He allowed as how he might be "too New England,"[29] but he could not for long tolerate the volatility of Mexico, and with relief he sailed in April 1933 for Germany, where he quickly began to restore his "pleasure in existence" after the rigors of Mexican life. As he geared up to begin painting, he found the writings of the likes of Plotinus and Santayana sustaining. Plotinus was his "idea of a true thinker," he observed, believing that "modified mysticism through mind processes suits me perfectly." He had given up all else and "read the Christian mystics as novels."[30]

He enjoyed life in Hamburg, where he spent part of the summer, and in his words, "established my means of escape into a new life now— Mexico began it—and it is only the soul of the north that will complete it for me." He had "come back to nature pure & simple again" and hoped never to leave it. This returned him to America "symbolically & mystically," he thought, and now he heard "the voices of Emerson, Thoreau,

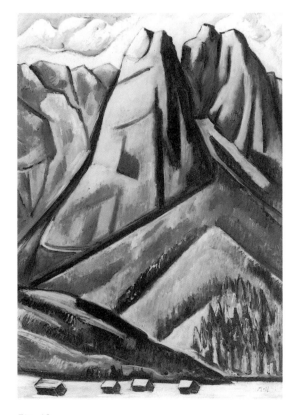

Fig. 12
WAXENSTEIN GARMISCH PARTENKIRCHEN, 1933–34
Oil on board, 29 3/4 x 20 3/4 inches
Vanderwoude Tananbaum Gallery, New York

[and] Emily Dickinson and they are true voices—they belong to my space—my innate areas," he declared.[31] In this mood he wanted to get back to mountains, which—since his visit with the German artist Fanz Marc many years earlier—fascinated him as symbols of the essence he sought in nature.

All this made him gravitate toward the Alps. Soon he settled in Partenkirchen, near the border with Austria, and immediately began "alpining," pleased to be "next to rocks & earth again." The Waxenstein peaks to the south made him exclaim that "there can be no single form more glorious in all the Alps than these are." He was sure that the central peak alone "would start another school of Chinese painting." It reflected his own interests when he praised the Chinese for their understanding of mountains, "the meaning of space, the significance of rhythm and the quality of time in appearances." Quickly he began making sketches—from the very simplest sort (*Waxenstein Drawing* [Fig. 11]) to more stylized silverpoint drawings—from which he expected to build other work, and he kept up this practice whenever the weather permitted until he left in February 1934. He noted the nearness of the mountains and the similarity of one, the Eckbauer, to Mont Sainte-Victoire. He thought of the mountains he had painted in New Hampshire, and of what he knew of Mount Katahdin in Maine. He considered his painting of the Alps to be a "proud preparation for recovering the 'eye' for the native scene"—that is, the New England landscape, which was exactly like the Alps "in structure & repetition." That Hartley picked up immediately on the closeness of the mountains is noteworthy. Anyone would have in a literal sense, of course, but what fascinated Hartley was that there was "almost no intervening atmosphere, as nothing is more than a mile from the eye, and as it is all shut in here, the play of light is very small or limited, so they just stand like monuments, a cross between Blake and the Chinese."[32] Hartley was not in a studied fashion creating modernist icons, but as monuments, the mountains became the subject of his paintings in ways they usually had not. Just as he had done with his paintings of Dogtown, he now lessened the distance between object and viewer so that one has a greater sense of the painter's having achieved Wallace Stevens's ideal of "not ideas about the thing but the thing itself."

In some of Hartley's paintings of the Alps, he included only the barest of foregrounds while others have no foreground at all, so that although the mountain is still clearly recognizable as such, it is foregrounded and flattened out and thus more than merely a part of the world beyond (*Waxenstein* *pl 18* *Garmisch Partenkirchen* [Fig. 12]; *Alpspitz-Mittenwald Road* [c. 1933–34]). The painting is totally an object that merges with the canvas and its viewer—exactly how the modernists would have had it be as they struggled

through their art to capture the world directly, without the intervention of conventional dogmas. Could philosophy intervene? Yes, but only insofar as it brought things into direct apprehension, which is one reason the mystics became so fascinating to Hartley and other modernist artists. "I think it must be [that] Plotinus has refined my sense of essence so much that I am able to see right down to the last detail," he told a friend late in December 1933.[33]

Not long after his stay in the Alps, in a collection of poems that he would call *Tangent Decisions,* he included two translations he had made from the work of Gerard de Nerval:

> How is it—I said to myself,
> that I can possibly have lived
> so long outside nature, without
> identifying myself with her?
> All things live, all things have
> motion, all things correspond.
> The majestic rays emanating from
> myself to others, traverse without
> obstacle, the infinite chain of
> created things….
> I want to govern my dreams, instead
> of endure them.[34]

Man, that is to say, is close to nature, entirely a part of it, and to express that, to govern his dreams rather than merely to suffer them, he has to come directly up to it, as in Hartley's German mountain paintings. If dreams emerge from the imagination, which takes whatever form it does from the relationship among the self, the unconscious, and the world beyond, then a person gains control by mastering the essence of nature, by rendering close up and precisely the monumental objects that represent it.

While still in Germany he was thoroughly content, situated among the Alps and enjoying a surge of creativity. He believed that he understood the mystics better than he had before. Ruysbroeck's dictum "perfect stillness—perfect fecundity" precisely conveyed his state of mind at this moment, or at least expressed what he strove for and now felt close to. And the divine for him was Plotinus's "supreme intellect," which seemed to represent that which was "more than ourselves," the "fourth dimension" that Cézanne had tried to paint. "I wish to paint that thing which exists between me and the object,"[35] Hartley wrote, attributing the original sentiment to Cézanne. That was what he was trying to do in his paintings of the Alps, and in the context of his comfortable, if solitary, life in

Partenkirchen, it gave him as much pleasure and confidence as he had ever had.

A lot had come together for him. What might be termed the healing process had begun in 1929 in Provence and, fueled by his reading and writing, had continued through his fertile Dogtown summer of 1931 and the emotionally turbulent year in Mexico, and had been completed during his lengthy stay in Germany in 1933–1934. Not that his life evened out for him until his death in 1943: Having returned to the United States in March 1934, he soon realized that the Depression meant that he was no better off financially than he had been in 1929. Early in 1935 he destroyed more than one hundred paintings and drawings because he could not pay storage on them. A year and a half later, having found deep contentment living with the Mason family in Nova Scotia, his happiness was shattered when the two sons, one of whom had become intimate with him, were drowned during a storm. Nevertheless, a sense of wholeness about things sustained him, allowed him to continue in the face of disappointment, and gave power to his work. And he continued to express his feeling of rapport in his writings, which poured forth perhaps more prolifically than ever before, although few of the essays written then were published. He addressed himself in a personal fashion to such diverse nineteenth-century figures as Henri Frederic Amiel, Richard Jefferies, W. H. Hudson, Herman Melville, and Henry David Thoreau, to mention but several. All were naturalists, but as art historian Gail Scott has observed, "they approached nature from a standpoint of visionary enlightenment, and struggled to describe and articulate nature's forms and ways, not for scientific knowledge alone,… but to find answers to the moral and spiritual predicament facing mankind in modern industrialized society." Like Hartley, these writers "found themselves outside orthodox religion, at a kind of crossroads between effete religious forms, mechanized society, and the primal forces of nature, and each sought solutions in the natural realm."[36]

For Hartley, at least, this crossroads was a cause not for despair but for wonder, for a celebration about things themselves, and for the emergence of an existential stance. It was marked not by an extreme alienation from the industrial age but by a sense of being a part of the essence that Santayana, among others of Hartley's literary heroes, sought to define. Hartley's art—both visual and written—from the last decade of his life has an acceptance, even at times a mood of calm, that is noteworthy. There is a remarkable tranquillity about many of his paintings of small creatures, *pls 19, 20* as in *Shell and Sea Anemones, Gloucester* (c. 1934); *Rope, Seashells, pls 27, 21 Starfish, and Jellyfish* (1936); *Shells by the Sea* (c. 1941–43); and *Crab, Rope, and Seashells* (1936). Like his hero Walt Whitman he came to

pl 22 accept death as part of the cycle of existence. *Insignia with Gloves* (1936) has overtones of his German officer memorials to Karl von Freyburg, though it is more directly an homage to Alty Mason, one of the men drowned in 1936 during a storm in Nova Scotia. And nowhere is there expressed a greater acceptance of the variousness of nature than in a late poem, *In Robin Hood Cove.* "The tide comes in, and out goes tide," it begins,

> it skirts the cliffs, and in their shadows sees
> the remnants of the days that fall
> between a seagull's and a robin's call.
> There is a bridge, and under flows
> the rest of evening with its primulous
> shows.
> It is a river made of listless sea
> after it has explained its fierce integrity.
> No thunder makes, or on rock heaves,
> it learns the place for plain humility,
> and keeps reflection of some mindless
> leaves.[37]

So too is his hard-won peace reflected in paintings such as the human

pl 25 figures he produced (*The Lifeguard* [c. 1940], *Fishermen's Last Supper* [Fig.
pl 26 13]), and the numerous works he did of Mt. Katahdin (*Mt. Katahdin* [1941]) in the Maine woods after a pilgrimage he made to it in the fall of 1939.

Among the best of Hartley's figurative works are those that he painted to honor the Mason family. In particular, Hartley painted two works he called *Fishermen's Last Supper*, the first, more overtly symbolic, in 1938. Over the heads of the two Mason sons, Alty and Donny, are eight-pointed stars, and on the tablecloth in the foreground are the words "Mene, Mene," referring to the Old Testament tale of God's handwriting on the wall that found King Belshazzar wanting because of his defiance, which Hartley likened to Alty's headstrong nature and his foolhardy gesture against nature of trying to row home in the teeth of a violent storm. Hartley hoped the first version might be enlarged into a mural, but that did not occur, so in 1940 he began a second, larger version of the painting (*Fishermen's Last Supper* [Fig. 13]). This painting is more poignant than the first because the symbolism is less blatant, although the three empty chairs facing the five members of the family remain, representing the drowned sons and their cousin—or perhaps Hartley, absent after the deaths of the three men.

In place of the eight-pointed stars over the heads of Alty and Donny

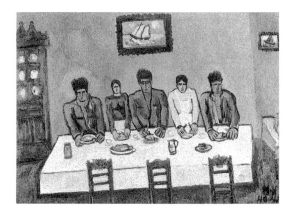

Fig. 13
FISHERMEN'S LAST SUPPER, 1940–41
Oil on board, 29 7/8 x 41 inches
Roy R. Neuberger

is a lightened blue against the darker hue of the wall behind, suggesting a spirituality about the young men as well as the possibility that Hartley initially had painted stars or halos over their heads. The figures of the family, while primitivist in style—Hartley called these figures "archaic"—are more fully rendered than in the first version and dominate the picture more. Hartley had literally fallen in love with the Mason family when he met them in 1935, "a most amazing family of men & women the like of which I have never in my life seen," he told Adelaide Kuntz. He called them "veritable rocks of Gibraltar in appearance the very salt of salt," and added, "how I would love to paint a series of them all." Two days later he wrote Adelaide Kuntz again and asserted that "if I did murals, I'd do one of the family at supper or noon meal—the table is long and narrow—I in the center—Donny right—Alty left—and sister [Alice] on the other side—walls blue furniture black—mama always in black with white apron—boys and papa in overalls—all dark and mystic looking—already I even think of doing studies of the men next year." The paintings he did of the family were close to what he had described in 1935, but the boys had died, so some of the motifs had changed, although his feelings toward the Masons had not: he called the family at their table "an epic sight…such a sense of unity—as they all loved and admired each other & were so gracious to each other at all times & that is what love and harmony can bring forth when two parents are perfectly joined."

Regarding the Maine landscape—and his experience painting Mount Katahdin in particular—Hartley wrote to a friend, "I know I have seen God now. The occult connection that is established when one loves nature was complete—and so I felt transported to a visible fourth dimension—and since heaven is inviolably a state of mind I have been there these past ten days."[38]

Lucky man! Not many modernists, weighed down by the burdens of a complex industrial society, could announce that. His was a particularly nativist assertion, reflecting the transcendentalism that lies at the root of much of the nation's thought and making him far more representative of American modernism than is usually acknowledged. Struggling as he did earlier in his career to escape the force upon him of his native land, he could never really succeed. The blending of foreign cultures and the sexual releases they provided, as well as all that he read and the deep feeling he had for his own land, enabled him, finally, to write and—most importantly—to paint as he did late in his life. He celebrated with color and tenderness "all things both great and small" (*Shells by the Sea* [c. 1941–43]), while never for an instant ignoring the destructive force that is also part of nature. It is not inappropriate to liken his work to the poems of his friend William Carlos Williams, that most American of modernists, who declared, "No ideas but in things." *pl 27*

FOOTNOTES

Author's note: In this essay I have drawn from my study, *Marsden Hartley: The Biography of an American Artist* (Boston: 1992).

1. Gail Scott, ed., *The Collected Poems of Marsden Hartley* (Santa Rosa, 1987), 250.

2. "The Ivory Woman," *Little Review* V (December 1918), 26–27.

3. Scott, ed., *The Collected Poems of Marsden Hartley*, 101.

4. Hartley to Rebecca Strand, summer 1929, Archives of American Art (hereafter cited as AAA).

5. George Santayana, *Winds of Doctrine and Platonism and the Spiritual Life* (New York, 1957), 260.

6. Ibid., 247.

7. Ibid., 254.

8. Ibid., 274.

9. Ibid., 279.

10. Ibid., 300.

11. Hartley to Adelaide S. Kuntz, summer 1929, AAA.

12. Hartley to Alfred Stieglitz, 9 November 1929, Stieglitz Collection, Yale Collection of American Literature (hereafter cited as YCAL), Beinecke Rare Book and Manuscript Library, Yale University; Marsden Hartley, "St. Thérèse of Lisieux," *On Art*, ed. Gail Scott (New York, 1982), 161–162.

13. Hartley to Alfred Stieglitz, 9 November 1929, YCAL.

14. Scott, ed., *The Collected Poems of Marsden Hartley*, 109–110.

15. Hartley to Adelaide S. Kuntz, 16 July 1931, AAA.

16. Marsden Hartley, "Somehow a Past," unpublished manuscript, Hartley Archive, YCAL.

17. Hartley to Florine Stettheimer, 17 August 1931, YCAL.

18. *Flaming Pool* is in the YCAL.

19. Hartley to Carl Sprinchorn, 3 September 1931, Elizabeth McCausland Papers, AAA.

20. Hartley to Rebecca Strand, 30 September 1931, AAA.

21. Hartley to Alfred Stieglitz, 5 November 1931, YCAL.

22. "Somehow a Past," YCAL.

23. "Mexican Vignette," unpublished essay, Hartley-Berger Collection, YCAL.

24. "The Bleeding Christs of Mexico," unpublished essay, Hartley-Berger Collection, YCAL.

25. Hartley to Norma Berger, 21 July 1932, YCAL.

26. Hartley to Adelaide S. Kuntz, 27 June 1932, AAA.

27. Hartley to Adelaide S. Kuntz, 28 July 1932, AAA.

28. Hartley to Adelaide S. Kuntz, 17 February 1933, AAA.

29. Hartley to Donald Greason, 21 March 1933, AAA.

30. Hartley to Adelaide S. Kuntz, 24 June 1933, AAA.

31. Hartley to Adelaide S. Kuntz, 12 July 1933, AAA.

32. Hartley to Adelaide S. Kuntz, 7 September 1933, AAA.

33. Hartley to Adelaide S. Kuntz, 25 December 1933, AAA.

34. "Somehow a Past," YCAL.

35. Hartley to Norma Berger, 14 October 1933, YCAL.

36. Preface to "A Life in the Arts," ed. with an introduction by Gail Scott. Book manuscript in progress of selected essays by Hartley.

37. Scott, ed., *The Collected Poems of Marsden Hartley*, 282.

38. Hartley to Elizabeth Sparhawk Jones, 23 October 1939, YCAL.

Paintings & Commentary

Quotations in the explanatory text opposite each plate come from the Stieglitz Collection and the Norma Berger Papers, Yale Collection of American Literature, Beinecke Rare Book and Manuscript Library, Yale University; the Elizabeth McCausland and the Rockwell Kent Papers; the Adelaide S. Kuntz and Rebecca Strand correspondence on microfilm at the Archives of American Art, Washington, D.C.; Barbara Haskell, *Marsden Hartley* (New York: Whitney Museum of American Art, 1980); Gail R. Scott, *Marsden Hartley* (New York: Abbeville, 1988); and Evelyn Underhill, *Mysticism: A Study in the Nature and Development of Man's Spiritual Consciousness* (New York: Meridian, 1955).

1

AUTUMN IMPRESSIONAL, c. 1906

I N this early landscape, Hartley's sense of the spiritual in nature, gathered from his reading of the works of Ralph Waldo Emerson and Walt Whitman, and more particularly from his nascent sense of identity with his native state of Maine, is apparent. In this composition his mastery of the "stitch stroke," a post-Impressionist technique that he learned from seeing reproductions of the work of Giovanni Segantini, is fully evident, as is the planar description of space, which would characterize his work for the next twelve years.

Oil on canvas, 30 x 30 inches, collection of The Vault Art Trust, Boston, courtesy Babcock Galleries, New York

2

MUSICAL THEME (ORIENTAL SYMPHONY), 1912–13

AFTER arriving in Paris in April 1912 Hartley reveled in modern art, experiencing that of Picasso, Cézanne, and Matisse in particular. As the summer wore on he understood the development of Cézanne's style toward Cubism. He was greatly influenced by Picasso and by Gertrude Stein's approval of his first attempts at "mystical abstractions," and was deeply affected by his readings of Wassily Kandinsky's *On the Spiritual in Art* and *Der Blaue Reiter*, the almanac produced by a group of German Expressionist artists centered in Munich. During the summer he told Stieglitz that Picasso's gift of "visualizing his sensations" was important and that as a result of it and other art he was absorbing he felt "certain spiritual metamorphoses taking place." He also remarked, "I find growing in me and I think to more purpose—a recurrence of former religious aspirations—taking finer form in personal expression."

The essays in *Der Blaue Reiter* focused on the spiritual and had a significant impact on Hartley's art for the rest of his life. August Macke, one of the German painters, wrote that "form is a mystery to us for it is the expression of mysterious powers. Only through it do we sense the secret powers, the 'invisible God.'" There was also composer Arnold Schönberg's essay dealing with mystical expression in music. Late in December 1912 Hartley wrote Rockwell Kent that he was trying in his Musical Theme series paintings "to express my emo-

tions of the cosmic scene in general." He had departed from Cubism, he believed, and was presenting "a sensation of cosmic bodies in harmony with each other, by means of color & form." Looking at the paintings on the floor of his studio, he told Kent that

> They look like a conclave of universal elements confiding in one another—things that look like stars—birds' wings—sun rays— suns themselves at the sundown time— moon shapes and star beams all radiant together. It is a kind of cosmic dictation applied aesthetically to produce a harmony of shapes & colors—with a sense also of the color of sound as I get these feelings out of music.

This passage describes his intentions, but does not mention the specifically spiritual and musical symbols he included in works such as *Musical Theme (Oriental Symphony)*. Although the shapes in the painting are clearly delineated in a way that became a signature of Hartley's work, he applied his oils thinly so that each shape would not blare out but work in harmony with the others. Musical staffs, clefs, eight-pointed stars, hieroglyphic marks, a sitting Buddha, and three hands signifying the Indian sign "have no fear" combine as an excellent example of what he termed "intuitive abstractions," his own "cosmic cubism."

Oil on canvas, 39 3/8 x 31 3/4 inches, Rose Art Museum, Brandeis University, Waltham, Massachusetts
Gift of Mr. Samuel Lustgarten, Sherman Oaks, California

28

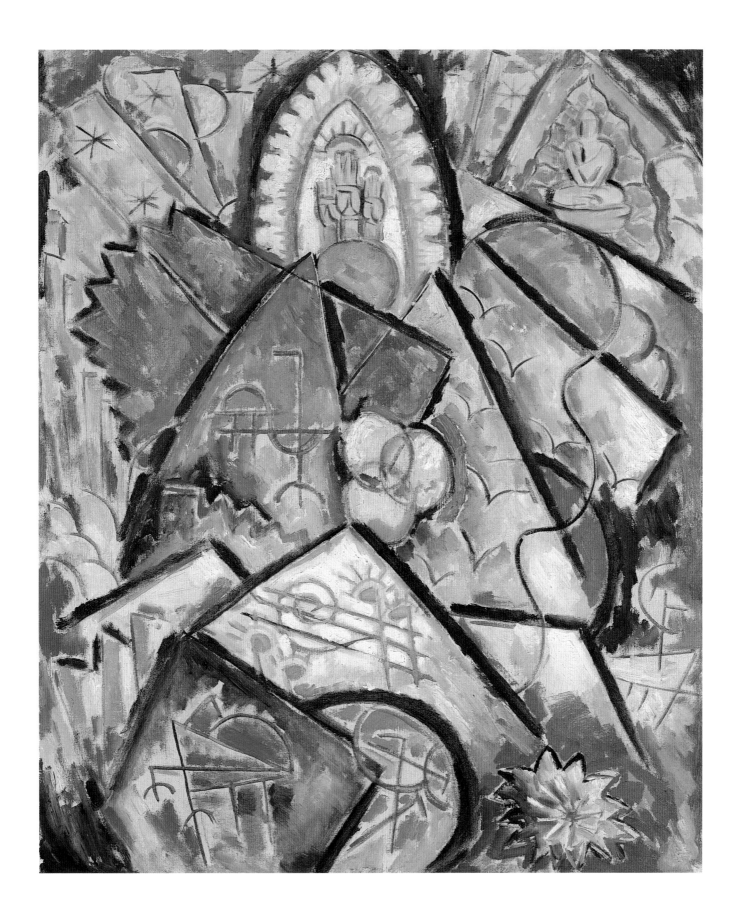

3
INDIAN FANTASY, 1914

IN Berlin in 1914 Hartley painted a series of works on the theme of the American Indian, inspired at least partly by works on the same theme by German artists. *Indian Fantasy* celebrates Native American culture through its various artifacts, such as teepees, headdresses, and earthen pots, all the while including earthy colors and forms, such as eight-pointed stars (the number is a symbol of regeneration and of the balance between the spiritual and the natural), which he employed in numerous of his Berlin paintings of 1913–15. While thoroughly American in subject and spirit, the painting is also in keeping with the technical and stylistic innovation he was experimenting with at the time. When a critic for the *New York Times* saw *Indian Fantasy* at a 1915 exhibition of Hartley's work, he wrote that the painting depicted a "cross between an ancient Egyptian and an ultramodern American eagle, brooding over a sultry lake on which four stolid cigar store Indians are drifting in a canoe."

Oil on canvas, 46 11/16 x 39 5/16 inches, North Carolina Museum of Art, Raleigh, purchased with funds from the State of North Carolina

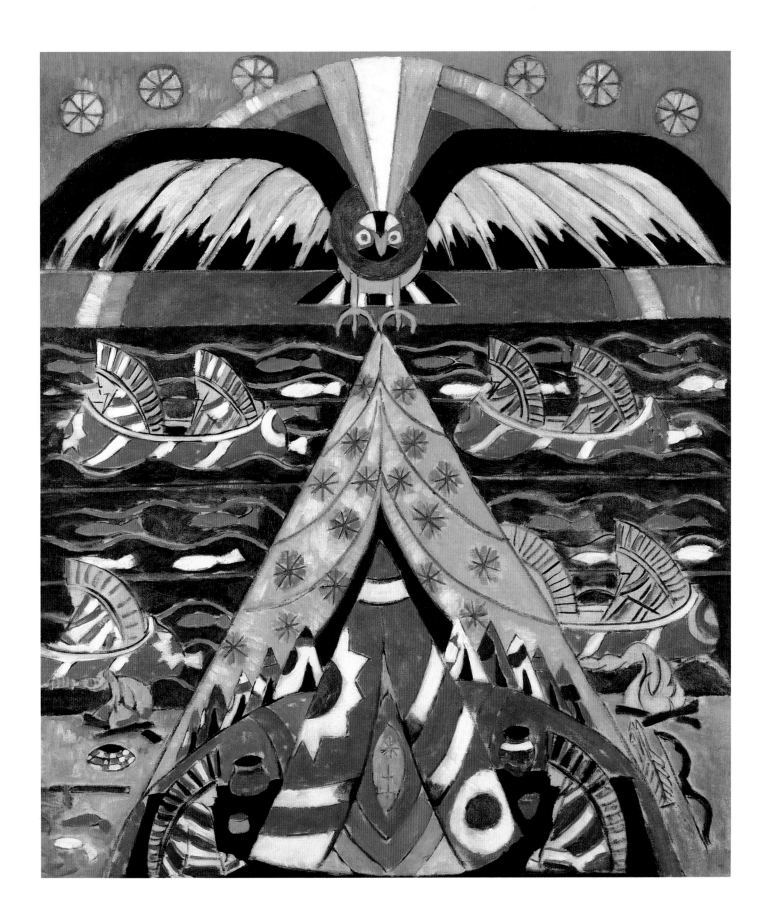

4

THE IRON CROSS, 1915

TYPICAL of Hartley's major series of German Officer paintings, *The Iron Cross* makes reference to Karl von Freyburg, a young German whom he had met in Paris and with whom he had fallen in love. An early casualty of the First World War, von Freyburg was posthumously awarded the Iron Cross, and Hartley here memorializes the symbols in which he perceived something of the young soldiers, military vanity, and personal spiritualism. The number *4* signifies his regiment in the Kaiser's Guards. Arnold Ronnebeck, another intimate friend of Hartley's, told the collector Duncan Phillips that an *E*, red on yellow, represented "the initial of Queen Elizabeth of Greece." Early in World War I Ronnebeck wore the insignia when he served "as lieutenant in the reserve of Konigin Elizabeth Garde Grenadier Regiment Numer 3." As the series progressed, those colors, as well as others included in a variety of designs, became "more purely decorative combinations of abstract patterns," the art historian Barbara Haskell has pointed out. When some of the series were displayed in the 1915 Berlin exhibition, one critic mocked Hartley as "A New American Misfit Genius" whose catalog introduction "screeches" that "it's all rot, what has so far been painted—rot, rot, and again rot.... I, I furnish the only real painting. I Marsden Hartley from Mixed Pickles in Bluffagonia." Here Hartley took his stand, knowing he had created an important new visual statement within the context of modernist painting. In full command of his imagery, Hartley authoritatively asserts himself as a leading painter of the modern generation.

Oil on canvas, 47 1/4 x 47 1/4 inches, Washington University Gallery of Art, St. Louis, University purchase, Bixby Fund, 1952

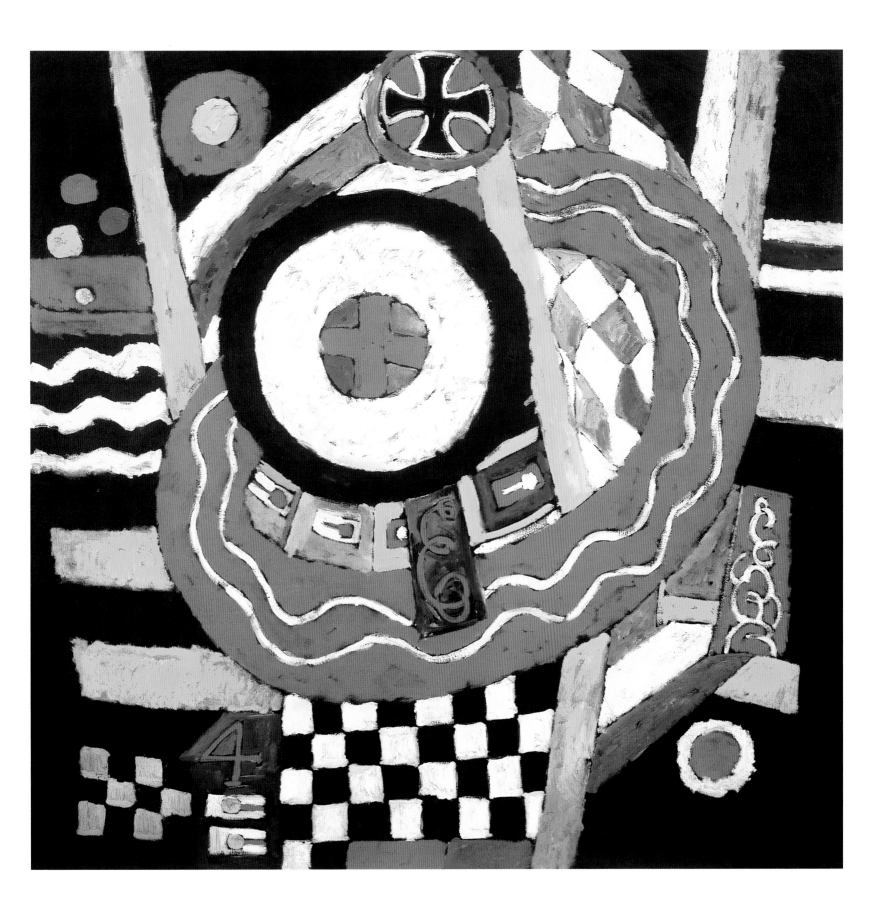

MOVEMENT NO. 3, PROVINCETOWN, 1915–17

THIS painting is one of several examples of the remarkable Cubist works Hartley did primarily during what he later called "The Great Provincetown Summer" of 1916. Earlier that year he wrote a catalog note for the Forum Exhibition in New York in which he declared that "Objects are incidents…. An apple does not for long remain an apple if one has the concept. Anything is therefore pictorial; it remains only to be observed and considered." While many observers believed in retrospect that this work marked the beginning of a lengthy fallow period for Hartley, Barbara Haskell called his Provincetown paintings his "most radical venture into non-objectivity" and likened them to work then being done in Europe. No American artist would rival them for a decade, but she added, they "proved too advanced…for even the more sympathetic cosmopolitan admirers of his painting to appreciate." Hartley was the most cosmopolitan painter of his time, and no perception of American provincialism could stay the power of his brilliant and enormously productive achievement during those years.

Oil on board, 20 x 16 inches, collection of Dr. and Mrs. Henry Kaufman

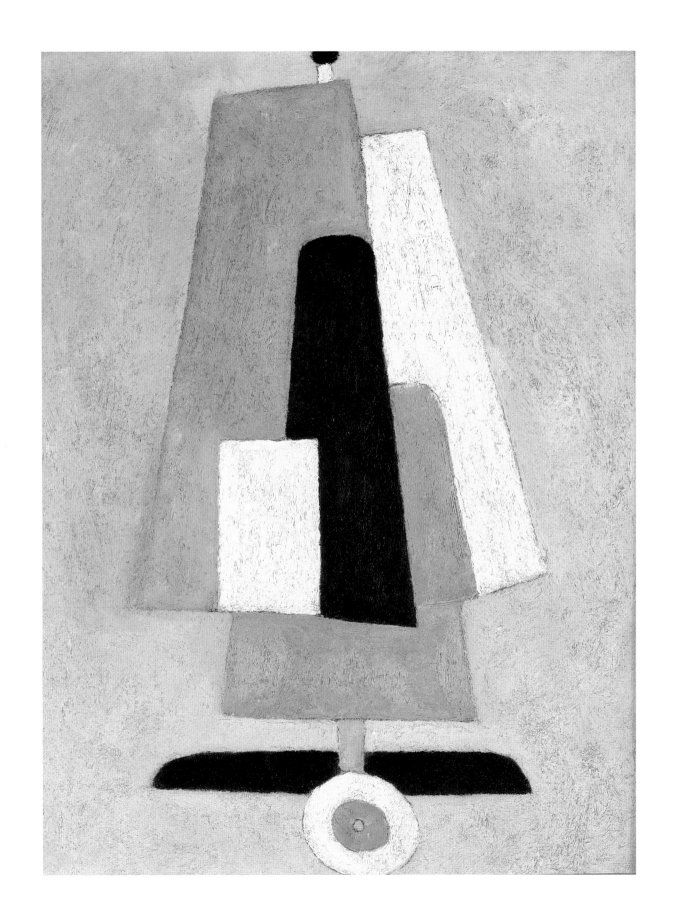

6

ATLANTIC WINDOW IN A
NEW ENGLAND CHARACTER, 1917

AFTER spending much of the fall of 1916 in New York, Hartley traveled to Bermuda as the year ended. He expected to find it "a place where I can hide and hush myself into a respectable belief in continuity and order." But Bermuda failed him: it was too placid; life was too sluggish; and he found it "essentially a place for [the American Impressionist Childe] Hassam, or for the lady painters—it is literally the colored photo." Even the presence of Charles Demuth, Charles Hawthorne, Ambrose Webster, Georgia O'Keeffe, and Albert Gleizes did not rectify matters, and as Hartley had done the previous summer in Provincetown, he continued to move away from the tumultuous works he had made in Europe and from the abstractions of the previous year. He had always associated the abstract with the mystical, but in 1917 he believed he was "rapidly outliving that" and hoped to "extinguish it all together, that is from an aesthetic point of view." His distrust of nature and the mystical stemmed from his "loss of illusions" that had resulted from World War I and the loss of German friends. He had moved less far than he believed, however; canvases such as *Atlantic Window in a New England Character,* probably painted during the summer of 1917, and a nearly direct imitation of a Bermuda painting entitled *A Bermuda Window in a Semi Tropical Character* (1917) are about form but are not stationary. Heavy application of paints, strong colors, and movement within the pictures produce vitality and emotion typical of Hartley's previous work.

Oil on board, 32 x 26 inches, collection of Harvey and Françoise Rambach

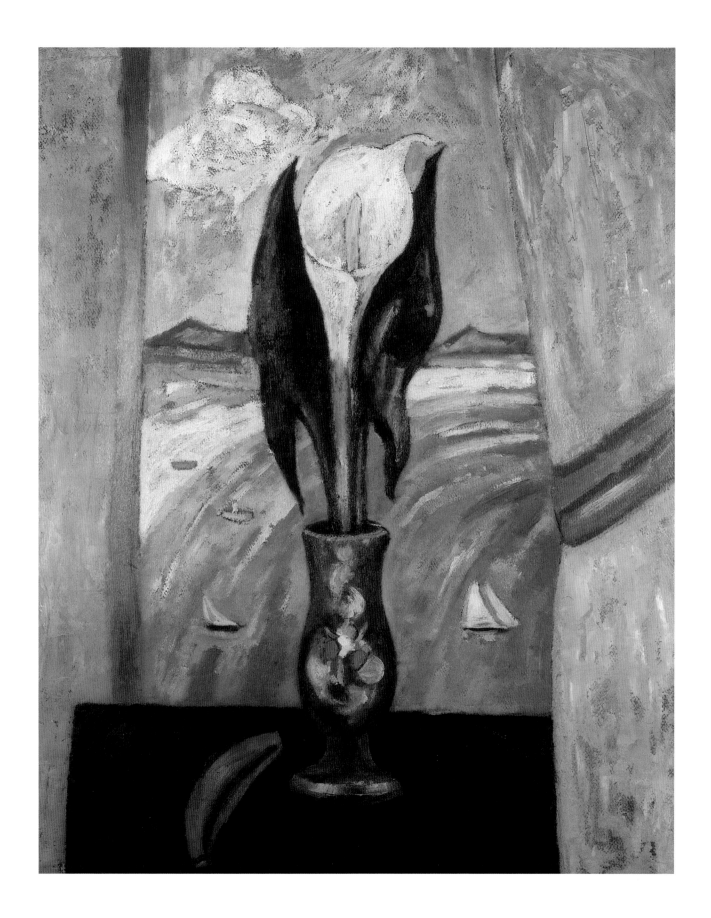

7
CACTUS, c. 1918-23

IN June 1918 Hartley traveled to New Mexico and quickly went north from Santa Fe to Taos, where he stayed near Mabel Dodge Sterne (soon to be Luhan). He immediately became entranced by the landscape, its colors, the clarity of the light, and the ambiance created by the mix of three cultures: Native American, Hispanic, and Anglo. He recognized that the land around Taos had "certain peculiarities" about it, which took some time to learn to render. So he first worked outside in pastels, and then by late July had two large still-life paintings under way, of which *Cactus* is possibly one. He told Alfred Stieglitz that his work was "quite interesting, in that it shows, and of course naturally, the result of so long speculating with abstractions." *Cactus* has something of the flatness of shape that his Provincetown work has, yet it also has a sculptural feeling for form, which Hartley believed was inherent in the New Mexico experience.

The profound sculptural forms of the cactus plant were a distant reference to the religious icons he was encountering, specifically santos figures, and were probably symbolic of the spirit Hartley found in the nature and lifestyle of New Mexico. Its colors anticipate his increasingly self-assured landscapes. One can speculate that the size of this painting and its close focus on the cactus suggest Hartley's sense of its iconic immensity in the minds of those familiar with the New Mexico landscape. In fact, the cactus is a kind of symbolic memorial in the same way that the German Officer series paintings are. It is possible that the painting might have been done when Hartley returned to Berlin in 1922 and was working on his New Mexico Recollections series. The *Cactus* palette is similar to that of the Recollections series. The painting probably dates earlier, however, and is a talisman of the New Mexico Recollections series paintings.

Oil on canvas, 39 x 23 inches, courtesy Babcock Galleries, New York

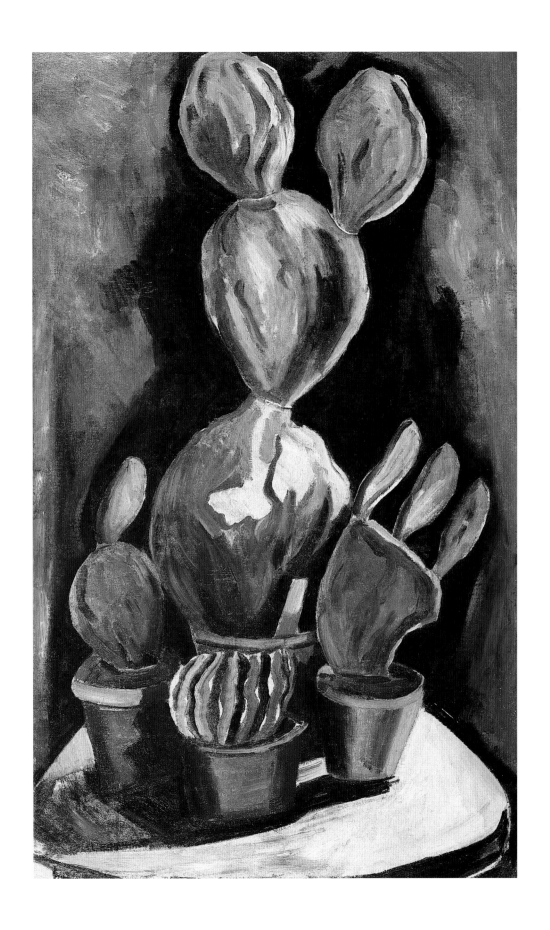

8
NEW MEXICO LANDSCAPE, 1919

IN the second of two essays published in the little magazine *El Palacio* in December 1918 Hartley declared that he was "an American discovering America." He wanted to capture the "stark simplicity, and...solidity" of the region around Taos and Santa Fe. In the first essay he asserted that painters had to comprehend that "the country of the southwest is essentially a sculptural country....The sense of form in New Mexico is for me one of the profoundest, most original, and most beautiful I have personally experienced." After spending several months in 1919 in California, he returned to Santa Fe with a sense that he understood the shapes and meanings of the countryside, and he began painting with a "Courbet intention," he told Stieglitz, by which he meant that he was clear of the obscure, "spiritual" paintings done in Europe. As he described it, his new work had "the abstraction underneath it all now & that is what I was working toward & what I deliberately set out to do down here."

Oil on canvas, 30 x 36 inches, Philadelphia Museum of Art, the Alfred Stieglitz Collection

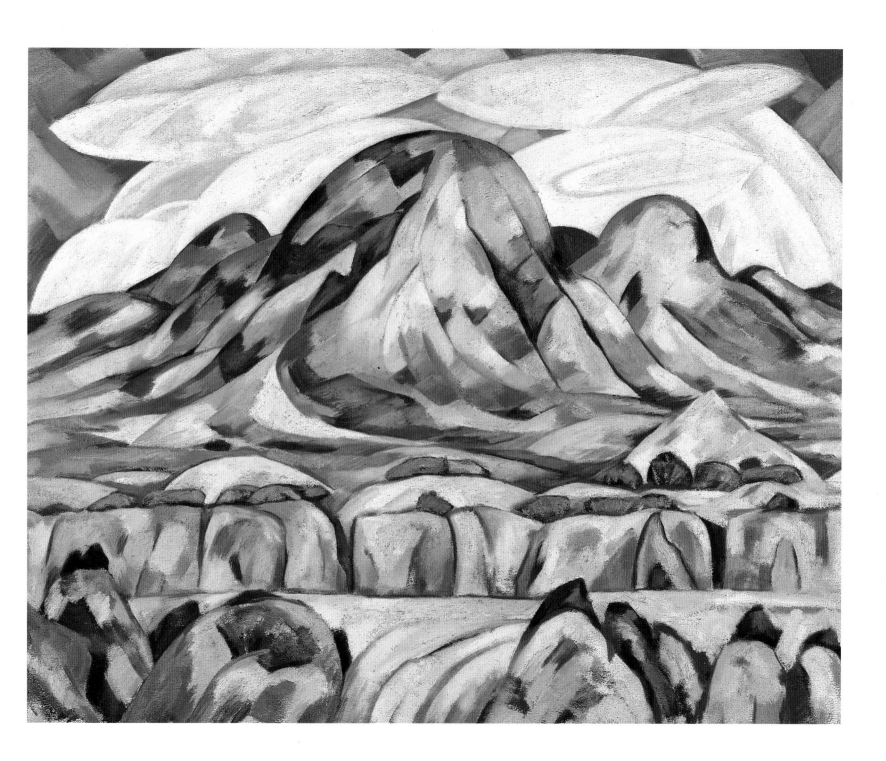

9

NEW MEXICO RECOLLECTIONS NO. 11, 1922

NOTED Hartley scholar Gail Scott has observed that the 1920s are often considered the artist's "lost decade," a period when his work was "eclectic, unrealized, and unfocused." While work of this period does not currently conform with popular tastes or notions of what people want from Hartley's work, it is clear that the '20s were a period of audacious experimentation and significant achievement. During those years he painted a powerful series of recollections of New Mexico and Texas as well as impressive landscapes of Provence and many challenging still lifes. Some of these equal his best work—they are hardly the thrashings of a painter gone astray. In New York in 1920 he thought back to the vast horizontal spaces he had recently studied in the Southwest and the images preyed on his mind until, settled in Berlin in 1922, he felt composed enough to begin his memory paintings. His German friend Arnold Ronnebeck recalled that in the drabness of wintry Berlin, Hartley painted "the sunny hills of New Mexico!" As he worked on his series he enthused to Stieglitz that the recollections were "not pictures thank god—but paintings." They are some of his most forceful works, typified by mass, horizontal movement, upheaval, undulation, and sensuality in their shapes. Larger than most of his paintings, they have a monumental quality that reflects the space and power of the western landscape. In 1923 he told Stieglitz that his "series of New Mexican & Texas landscape inventions...[are] the best landscapes I've done...taking merely just the natural wave rhythms which are so predominant in that southwestern scene."

Oil on canvas, 30 x 40 inches, collection of Mr. Gary T. Capen

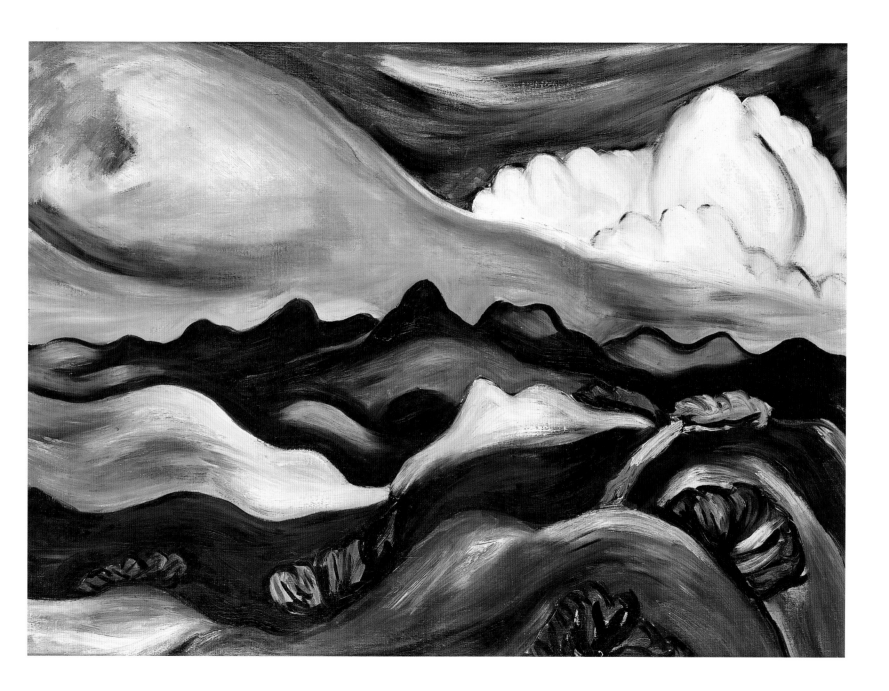

10
STILL LIFE WITH FRUIT, c. 1923

I N Berlin Hartley painted many still lifes in addition to the New Mexico Recollections series. Although Synthetic Cubism was much in vogue among German artists, as Barbara Haskell has noted, Hartley, while moving toward "even more painterly Cubist still lifes" than he had done previously, created paintings that "are freer and more spatially plastic than the flat, decorative style of late Synthetic Cubism." This reveals perhaps the extent of his referral back to the brilliant still-life paintings of Cézanne. It begins a period in which Hartley more thoroughly investigates the French painter's ideas and lays the foundation for important work throughout the final twenty years of his life. He thought he was achieving "just good old fashioned honest painting" such as Renoir, Cézanne, and Courbet cared about. All well and good, but in fully achieved work like *Still Life with Fruit*, Hartley always imposed his own demands on what he learned and experienced from others. In short, he embraced Cézanne and made him his own.

Oil on canvas, 14 x 31 inches, courtesy Babcock Galleries, New York

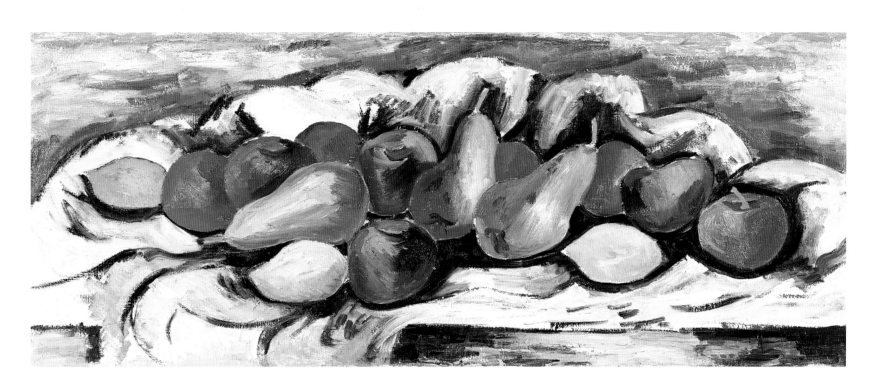

11
PURPLE VASE, c. 1925

THIS painting may be one of the first he rendered after making an agreement with an American named William V. Griffin and three of his friends to paint ten pictures a year for four years. Hartley was to receive $2000 per year. *Purple Vase* shows some of the rounded shapes evident in his New Mexico recollections, although already as in *Landscape No. 29, Vence,* Hartley was adopting the more blockish, elemental forms of his hero Cézanne. The size of the images; the brilliance and distinctness of the colors; and the intricate brushwork throughout are remarkable, as is Hartley's choice of brown, succulent-like leaves, two of which are provocatively pierced. The leaves echo an unknown symbolism, faintly felt but nonetheless real. In choosing the brilliant blue backdrop, the deep purple of the vase, and the maroon of whatever it is placed on, Hartley drew upon several of the primary colors of Provence while perhaps speculating on the spiritual iconic presence of the tongue-like leaves. The painting is no mere still life but a complex statement by an artist very much in control of his work.

Oil on canvas, 31 3/4 x 46 inches, courtesy Babcock Galleries, New York

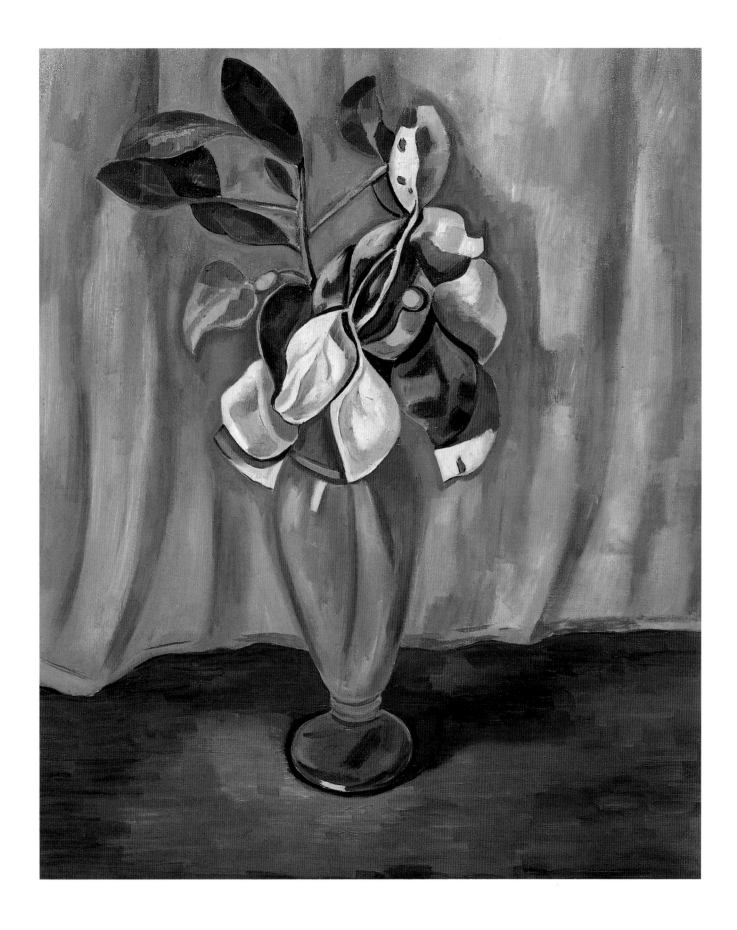

12

LANDSCAPE NO. 29, VENCE, c. 1926

THE title of this painting is confusing: while indicating Vence, it is actually a landscape of Cézanne's Chateau Noir with Mont Sainte-Victoire in the background. Biographical evidence suggests that Hartley painted this work in 1926 after seeing the mountain for the first time during his return from Paris to Vence in June. On his way to Paris he stopped for a day in Aix, then spent three more days there on his way back. While he might have painted *Landscape No. 29* after moving to a house two kilometers outside of Aix in September, there would have been no reason then to indicate Vence. What seems possible is that he began the painting from memory after seeing the mountain in late June and being deeply affected by Cézanne's work, doubtless having seen some of his paintings of Mont Sainte-Victoire.

The influence of Cézanne upon *Landscape No. 29* is abundantly apparent; Hartley assimilated the other artist's techniques and produced an original tapestry-like image. The delineation of colors, the clarity of shapes, and the intensity of the focused image are themselves iconic symbols of Cézanne perhaps in the same way the German Officer series paintings are iconic symbols of Karl Von Freyburg. Here the spiritual connection is with Cézanne, whom Hartley now claimed as an artistic forbear. Hartley wrote to Stieglitz about his reaction to the countryside of Aix: "Such color exists nowhere outside of the windows of Chartres & St. Chapelle—the earth itself seems as if it were naturally incandescent & seems fired from underneath somehow—yet withal so restrained & dignified. How remarkable that Cézanne should have found it to be so complete."

Oil on canvas, 19 1/2 x 24 inches, private collection, courtesy Babcock Galleries, New York

13
STILL LIFE WITH RED DRAPE, 1929

BOTH *Still Life with Red Drape* and *Still Life (with Garlic)*, executed near the end of Hartley's last extended stay in France, evidence Cézanne's effect on him. With intonations of Cubism quite apparent, the elemental forms and strongly delineated colors show Hartley's concern to render the fundamentals of what he painted—the "truth" about the objects, which was one way of approaching the spiritual. Early in 1929 he wrote his friend Rebecca Strand that he was working with a new technique, the effect of which was to make the objects appear to be "seen through windows or by mirror reflection." He thought he was achieving "almost selfless painting," and he craved "to remove all trace of 'inwardness.'" The image was to be "revealed as an immediate experience & not by thought or reflective processes." These two works have a forcefulness, a directness, which reveal his desire, as he quoted from the philosopher George Santayana, to "distinguish the edge of truth from the might of the imagination."

(continued on page 52)

Oil on masonite, 24 x 19 1/2 inches, private collection, courtesy Babcock Galleries, New York

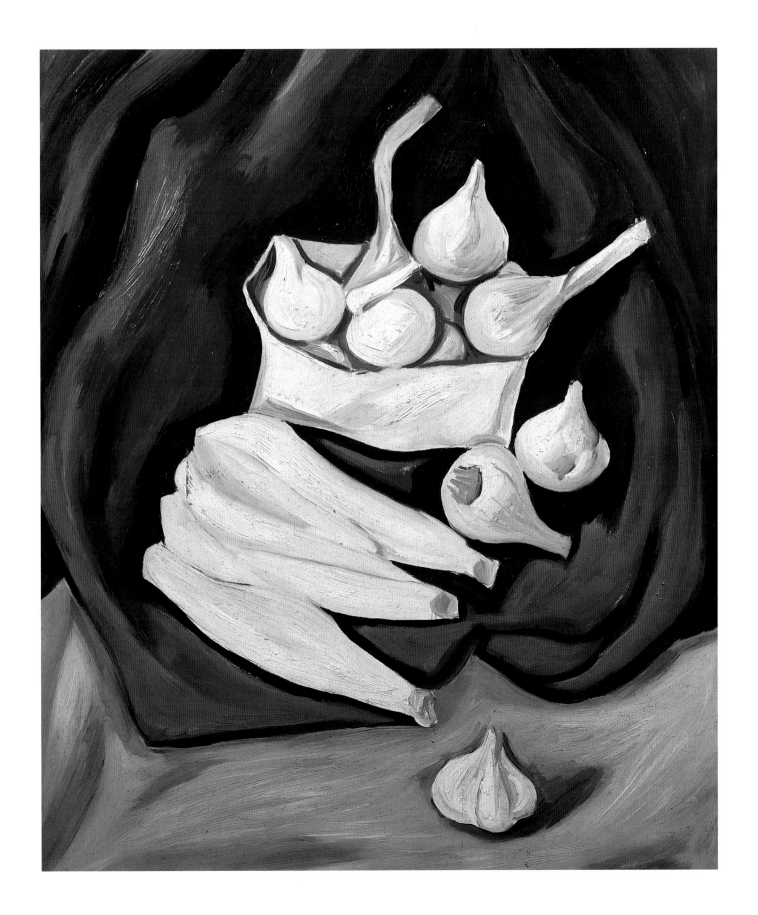

14
STILL LIFE (WITH GARLIC), 1929

(continued)

During the summer of 1929 in France, back in Aix but not painting landscapes, Hartley read avidly among the writings of philosophers such as Santayana and Miguel Unamuno, and mystics such as Sainte Thérèse of Lisieux, Jakob Boehme, John Ruysbroeck, and Johannes (Meister) Eckhart. "I value myself less & less," he told his friend Adelaide Kuntz; and to Stieglitz he asserted that "after all what is visible is all we can seem to know and the rest is left to romanticism & to ecstasy." He admired the mystics because they had "a sense of certainty." He did not, but they helped him toward "the edge of truth," which he strove to render in his work. "I had an excellent summer—spiritually speaking," he told Stieglitz in November shortly before leaving Provence. It is not too much to claim that the calm he needed to produce the fine work he did during the last decade and a half of his life commenced about this time, as he began to understand the need to mute what he termed his "ego-eccentricity" even though the personal could be—should be—part of "truth." In still-life paintings of this period, Hartley found the perfect setting in which to find in himself and his subject an expression of "truth."

Oil on canvas, 18 x 15 inches, courtesy Babcock Galleries, New York

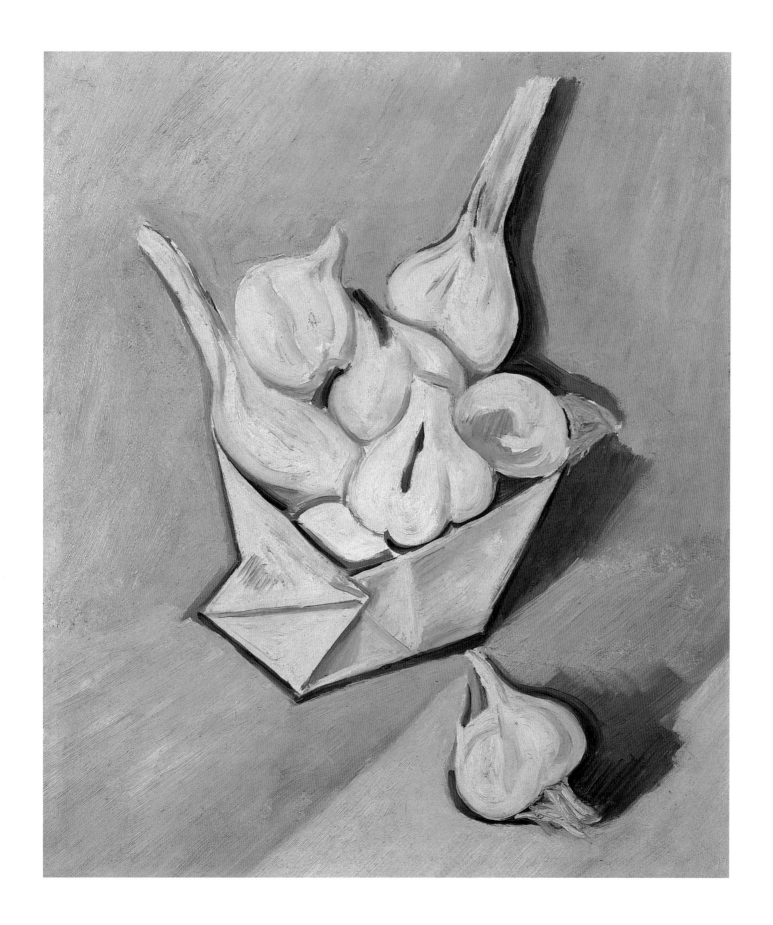

15
MOUNTAINS IN STONE, DOGTOWN, 1931

AFTER a rather desultory year of painting, Hartley returned in 1931 to Gloucester, Massachusetts, the famous fishing port on Cape Ann. He remembered it from a visit in 1920, and he hoped he would be able to draw sustenance from the artists' colony and the landscapes. Typical of Hartley, he scorned the port itself, much painted by the Impressionists and their followers. He quickly found Dogtown, an eighteenth-century settlement in the hills behind Gloucester. It was nearly empty of people now, and the stark landscape of boulders and many-hued brush created an eerie atmosphere. It was a "cross between Easter Island and Stonehenge," he told Adelaide Kuntz. To appreciate it required "someone to be obsessed by nature for its own sake, one with a feeling for the austerities and the intellectual aloofness which lost lonesome areas can persist in." *Mountains in Stone, Dogtown* is a magnificent example of the paintings Dogtown inspired. He held on to elements of Cézanne's still lifes while conveying a sure sense of the vitality and movement he found in the scene. Heavy brushwork and distinct blocks of color add to the force of the painting, whose earthly shapes are topped by a stylized tree, which is nothing so much as a cross that literally touches a cloud in the strong blue sky. Moved deeply by T. S. Eliot's 1930 poem "Ash Wednesday," about his search for meaning in faith, Hartley inscribed several lines from it on the back of another Dogtown painting.

During the summer and fall he worked to discern a clearer "vision for Life itself," he told the artist Carl Sprinchorn; and to his niece Norma Berger he wrote, "I have no recourse to superimposed faiths or beliefs to fool myself with into thinking that what is is all right.... What [an awful] thing it is—this indomitable will to live, and it is the body that persists when the mind sees through it all too acutely." He understood, he wrote Adelaide Kuntz during the fall, that "while my pictures are small—they are more intense than ever before, and I have for once [again] immersed myself in the mysticism of nature."

Oil on board, 18 x 24 inches, collection of Harvey and Françoise Rambach

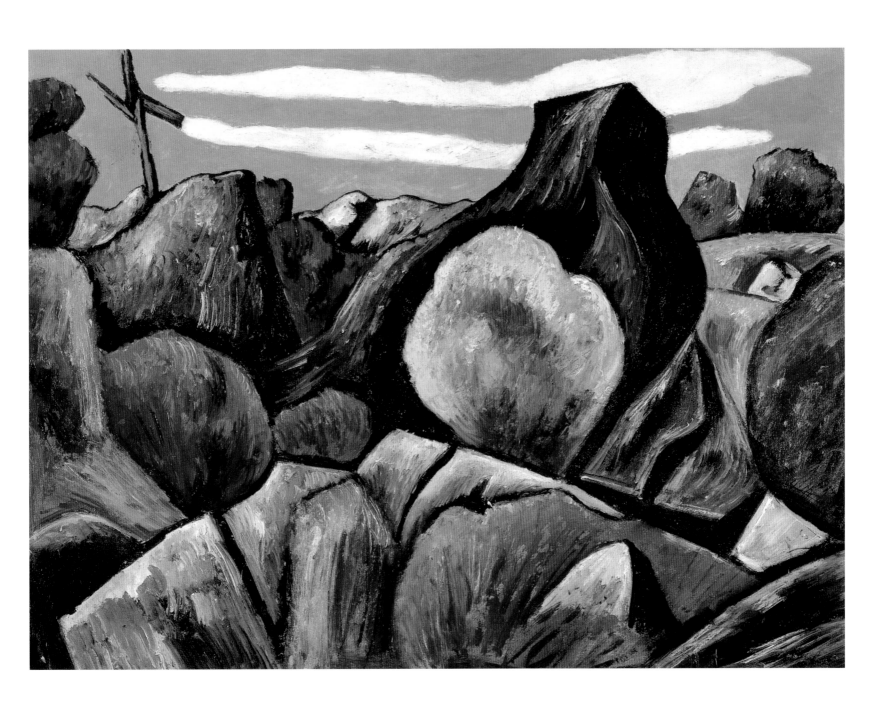

I N the early spring of 1932 Hartley traveled to Mexico on a Guggenheim Fellowship. While he was fascinated by many aspects of the culture, the Latin spirit and the vividness of the terrain were too much for him to absorb: "Grandeur of scene, splendour of race, smoldering volcanoes, fire coloured birds, the most amazing light eye has ever encountered...pestilence, miasmas, crocodiles, aigrettes, lizards, flame consuming the whole aspect of life," he wrote about Mexico in his memoir, "Somehow a Past." During his stay Hartley could never become acclimated to the country, so after shifting from Mexico City to Cuernavaca and reading deeply in a substantial collection of books about mysticism, rather than attempting paintings from nature he began working on "pictures of mystical import," one of which was *The Transference of Richard Rolle.* Hartley admired Rolle's (c. 1300–49) lyrical writing and his mystical faith, which was so intense that in his life he believed himself transferred into heaven. On the back of the painting Hartley wrote "Rolle first English mystic." Rolle became a hermit so as to perfect a life of "Heat, Sweetness, and Song." *Transference* is an homage to the spirituality of a man rendered by a skeptic (Hartley) who was moved by the religious fervor he observed in Mexico. The elemental landscape is Mexican and in the painting is linked to Rolle, whose "transference" is represented by the *R*s along the borders of the triangular cloud and inside the mystical golden triangle, a symbol of the Holy Trinity.

This and *Morgenrot* are part of a series that Hartley called *Murals for an Arcane Library.* These paintings, done under the duress of the alien environment of Mexico, remain among Hartley's least appreciated masterworks. Exhibited as a group in Mexico City in 1933, they coalesced much of what had gone before and are Hartley's most directly symbolic paintings since creation of the German Officer series. Here, however, a more mature painter, increasingly aware of his own mortality, seeks to express the iconic spirituality of his experience. From these deeply inspired paintings, the door opened to his last decade of work.

Oil on board, 28 x 26 inches, private collection, courtesy Babcock Galleries, New York

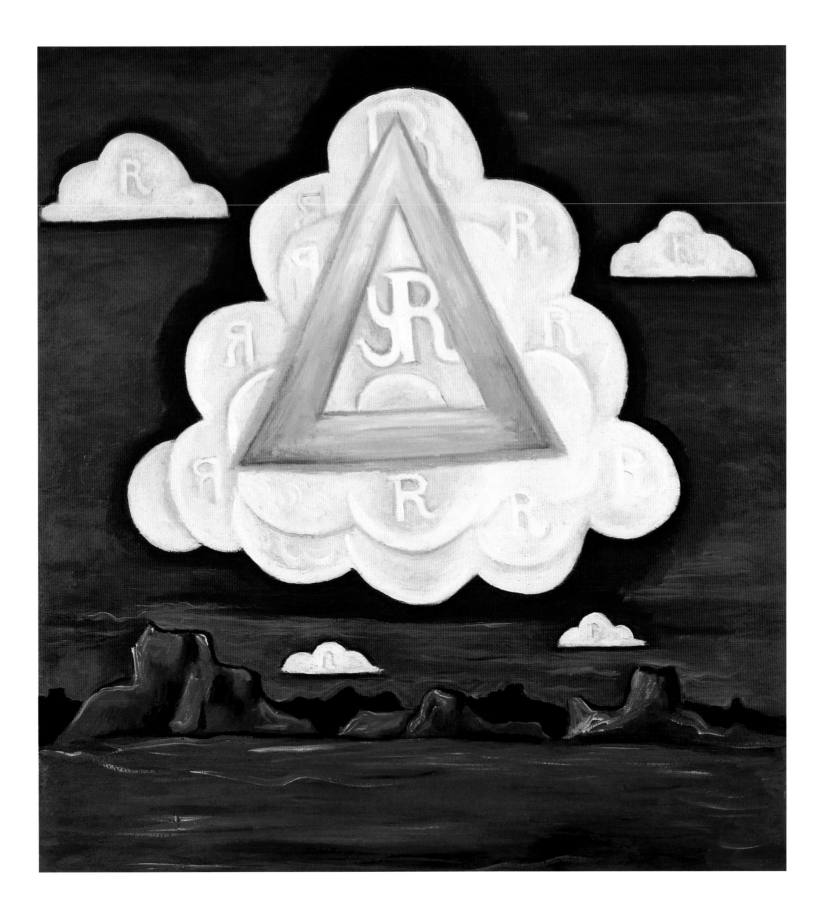

17

MORGENROT, 1932

(Morgenrot. La Mano de la mañana nace de la noche triunfante.)

WHILE the iconology of the paintings comprising the *Murals for an Arcane Library* series has not been definitively established, it is believed that this painting represents what the artist had been reading about in the work of the German mystic Jakob Boehme (1575–1624). For Boehme, the seventh realm of divine corporeality—or the materialized word—was where individual sounds contributed to the divine harmony of the spheres. In *Morgenrot* the seventh sphere is on God's divine hand made corporeal, 7 being a symbol of perfect order and completeness. The colors are those Hartley found throughout Mexico.

The scholar Evelyn Underhill has noted that according to the introduction to the English translation of Boehme's work, when he was young he had the first of several mystical illuminations. In this one "he was surrounded by a divine Light for seven days and stood in the highest contemplation and kingdom of joy." Underhill added that in Boehme's "first and most difficult book, the *Aurora* or *Morning Redness*"—"Morgenrot" in German—he tries to convey to the reader his perception of reality. There is, of course, much more to Boehme's vision than can be described here. The point is that Hartley's painting is a direct representation of one of Boehme's mystical illuminations.

The red hand is a reminder of the Indians, the land, the brilliant sun, and even the blood of man, all of which are parts of God made corporeal in the bright-red morning of the seven days during which Boehme had his first illumination and when all was in harmony. The painting shows how Hartley's mind was working in Mexico, when, steeping himself in mysticism but overwhelmed by the country, he painted out of the inspiration he had begun to recover in Dogtown and that he then integrated with elements of the native Latin culture.

Oil on canvas, 25 x 23 inches, private collection, courtesy Babcock Galleries, New York

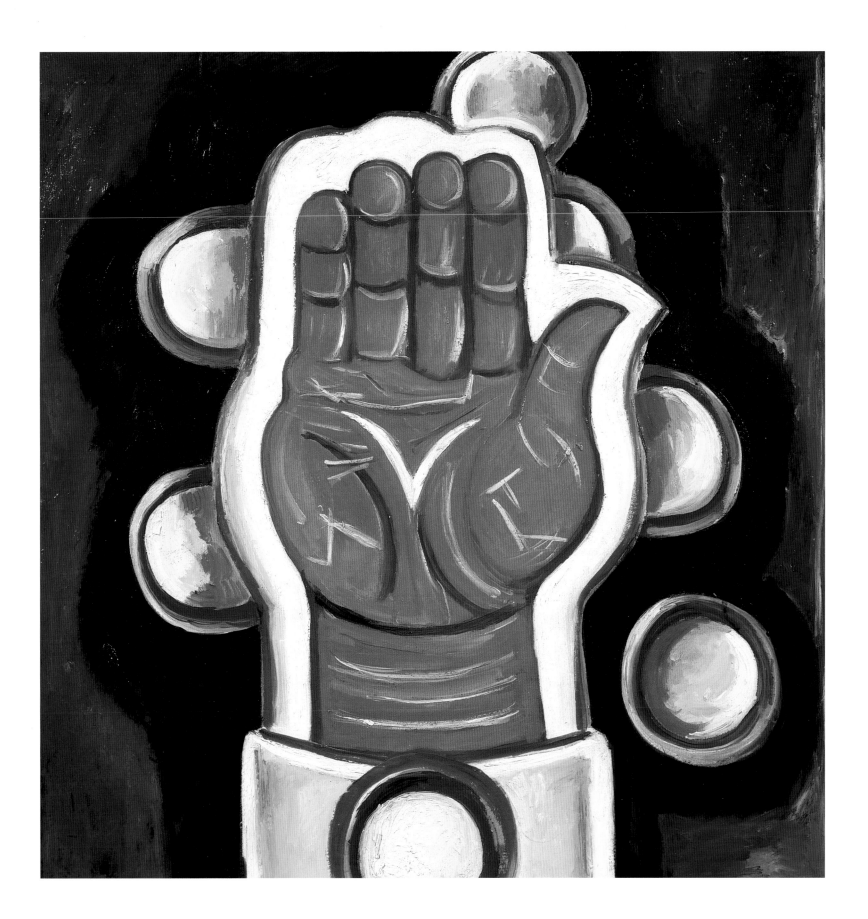

18
ALPSPITZ-MITTENWALD ROAD, c. 1933–34

In April 1933 Hartley sailed for Germany from Mexico. Once there he spent the summer in Hamburg before moving to Partenkirchen in the Bavarian Alps. He immediately began making detailed studies of the mountains in preparation for works such as *Alpspitz-Mittenwald Road*, a superb example of what he termed the "mystical nature" of the mountains. He was a "mountain person and a snow person," he told Adelaide Kuntz by way of explaining his desire to visit the Alps. He sought "to get all that back into my consciousness for good and all." A film about German alpinists, which he saw repeatedly in Hamburg "brought about a conversion to nature," he asserted. It had been "the religion that I began life with up in Maine, and I feel all aquiver with the new conversion as a result." As much as anything could, mountains symbolized for him power, potential destructiveness, yet immense beauty and stability. If nature had a design, for him dramatic peaks such as Alpspitz reflected it. He painted with a fervor: "I have never painted like I am doing now," he told Adelaide Kuntz in late December 1933. He told his niece, Norma Berger, shortly thereafter that he had "nearly finished 15 paintings and walked over 100 miles to make the drawings and observations." His last stay in the Alps added to his creative and spiritual renewal that had begun in Dogtown in 1931.

Oil on paper on board, 17 5/8 x 29 3/4 inches, Santa Barbara Museum of Art, gift of Mrs. Sterling Morton to the Preston Morton Collection

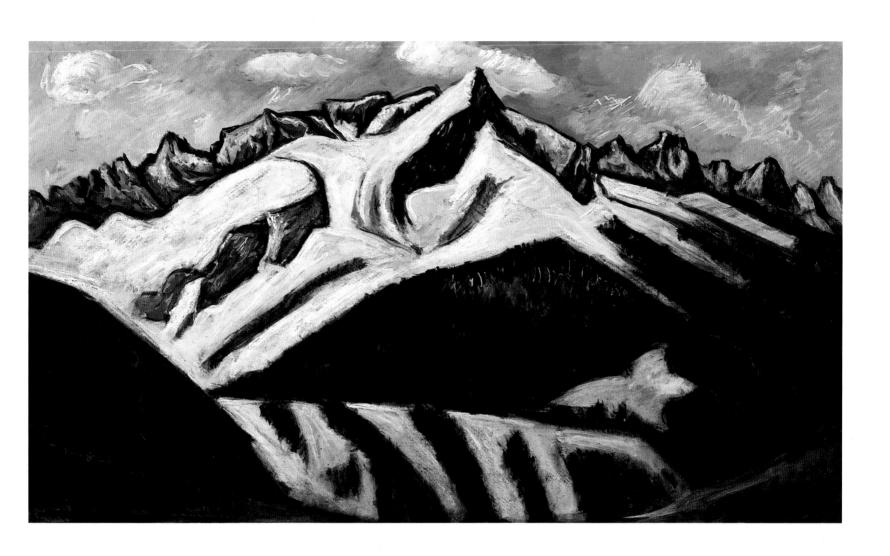

19

SHELL AND SEA ANEMONES, GLOUCESTER, c. 1934

IN early July 1934 Hartley returned to Gloucester, where he had last been three years earlier. He did a second series of Dogtown paintings as well as still lifes, some set in front of telescoped seascapes and some—such as *Shell and Sea Anemones, Gloucester*—depicted objects from the ocean, in this case a shell, sea anemones, a fishing dory, a lobster pot, and something that is perhaps a fishing net or a frame for drying it. The background, in no way realistic, sets the stage; the shell and anemones are sensitively treated as part of a sculpted portrait that pays iconic homage to "all the little live things," while also symbolically embodying the relationship of man to the sea. It was this sense of nature that Hartley would paint more and more of during the last decade of his life.

Oil on panel, 18 x 24 inches, private collection, courtesy Babcock Galleries, New York

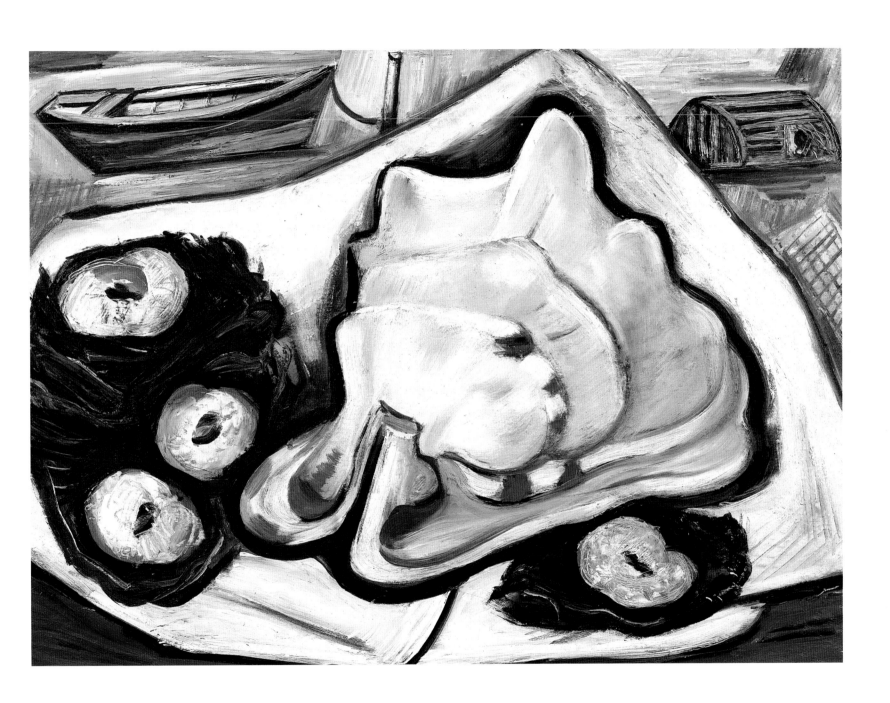

20
ROPE, SEASHELLS, STARFISH, AND JELLYFISH, 1936

IN September 1935 Hartley traveled to Nova Scotia, where he soon settled in Blue Rocks, near the fishing town of Lunenburg on the eastern coast. He quickly felt embraced by the people and the setting; the ruggedness of the ocean and the warmth, devoutness, and directness of the people with whom he stayed seemed a marvelous change from both cosmopolitan New York and the close-lipped meanspiritedness he associated with New England. In November, after meeting Martha Mason and her two sons, Alton and Donald, and asking her if he could stay with them, he moved to East Point Island where they lived. The island is a quarter of a mile across an inlet from Blue Rocks, and there he was able to live on intimate terms with the family and soon felt himself a part of it. He told Adelaide Kuntz that he intended to return in 1936 because "all this vital energy & force is too good to miss." He had never, he asserted, "been so near the real thing before...& it's all so new to me and enveloping." Early in the summer of 1936 he returned to East Point Island. Pauline Mason, who as a young child knew him that summer, recalled Hartley walking about the island with his hands clasped behind his back, peering closely at the nature he would soon draw. He told Adelaide Kuntz that he wished "to achieve something like myopic observation if not

(continued on page 66)

Oil on panel, 11 1/2 x 15 1/2 inches, private collection, courtesy Babcock Galleries, New York

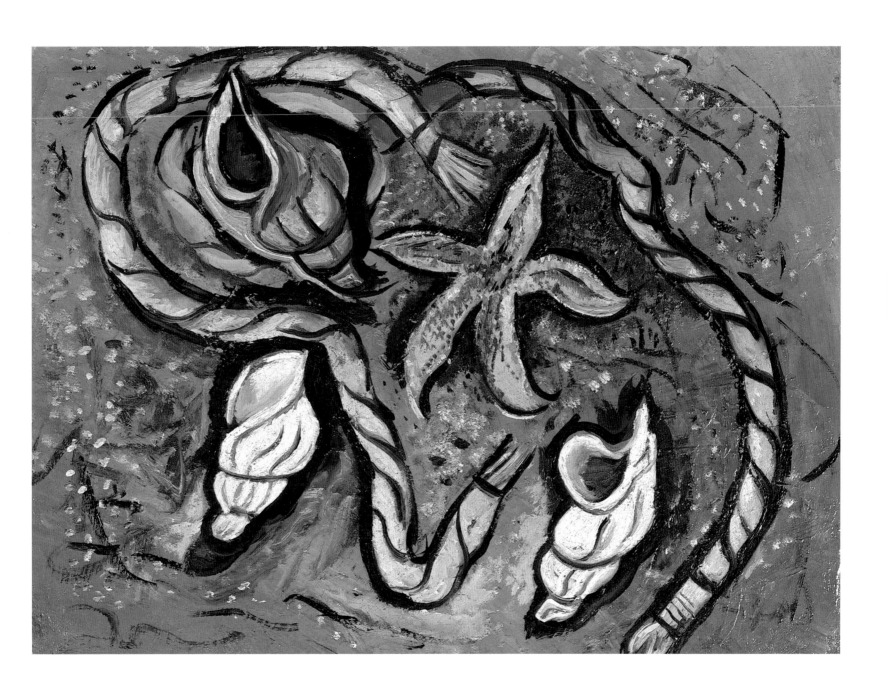

21
CRAB, ROPE, AND SEASHELLS, 1936

(continued)

exactly vision—The power to see minutely and exactly is a rare gift...." Sometimes during that summer he would walk into the center of the island, noticing the small things, "urchins, clam shells, & mussels in the deepest of the woods," which crows and seagulls had brought there. What he saw reminded him of both the abundance and the cruelty of nature, and as he absorbed all that, he imagined himself the "self-appointed spiritual owner of the island."

He painted in a small shed half-filled with fishing nets, coils of rope, lobster buoys, and other equipment. Amid the smells of fish and the ocean he worked on still lifes such as *Rope, Seashells, Starfish, and Jellyfish* and *Crab, Rope, and Seashells.* His corner of the shed, he told Stieglitz, was "full of sea shells, bleached crabs—cork floats—coils of rope that the sun has bleached white—& these then are the new subject matter which I try to make portraits of, and if there is a hint of the abstract in the result it is the quality of nature itself that rules for I want to have no emotion of my own." He was correct: "the quality of nature itself," more than in a stylized still life such as *Shell and Sea Anemones, Gloucester,* is what is conveyed by the clearly delineated objects, and is precisely what gives the later work its power. Nevertheless, it was his imagination and emotion that played upon what he saw; an artist could do no differently.

Oil on panel, 12 x 16 inches, private collection, courtesy Babcock Galleries, New York

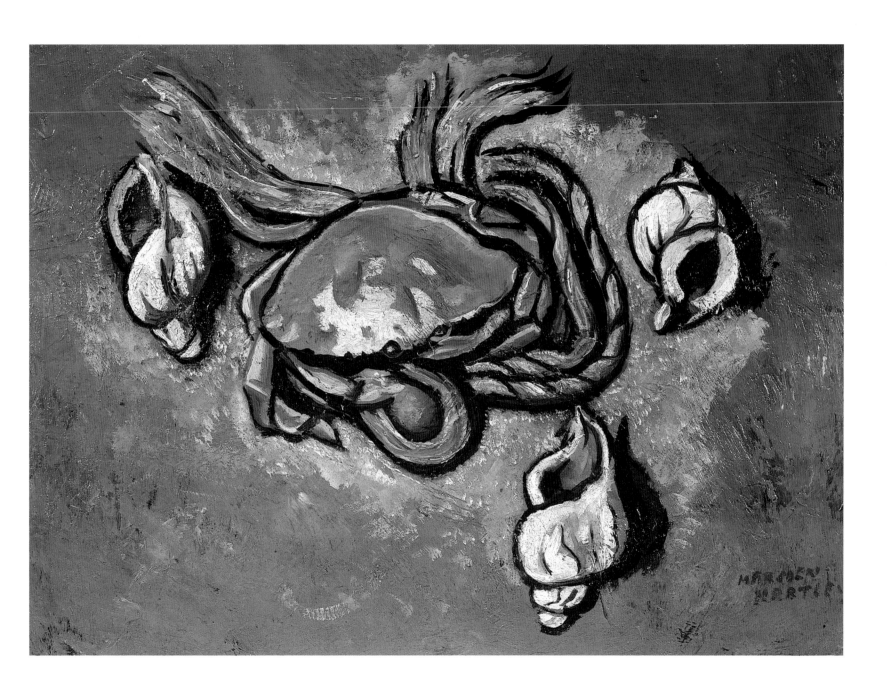

22
INSIGNIA WITH GLOVES, 1936

O N the night of September 19, 1936, the two Mason sons and their cousin Allen were drowned when they tried to return to East Point Island in a fierce storm after they had been drinking in Lunenburg. Their parents and Hartley were shattered by the event; he offered to leave, but the Masons asked him to stay. He did, and until his departure in November, he painted and wrote, pouring out his sadness in both mediums. He did seascapes of a somber, Ryderesque sort as well as still lifes of small animals and objects, such as the hat and gloves in *Insignia with Gloves.* The gloves are likely a pair one of the sons wore; the hat is one worn by a Bersaglieri—an Italian light infantryman. Its somber black suggests mourning, while the military origin and the vivid colors of the insignia are reminiscent of Hartley's German Officer series. The work can be read as an homage to three of the men Hartley loved most: Karl von Freyburg, and Alty and Donny Mason.

Oil on canvas, 20 x 28 inches, private collection, courtesy Joan Michelman Ltd.

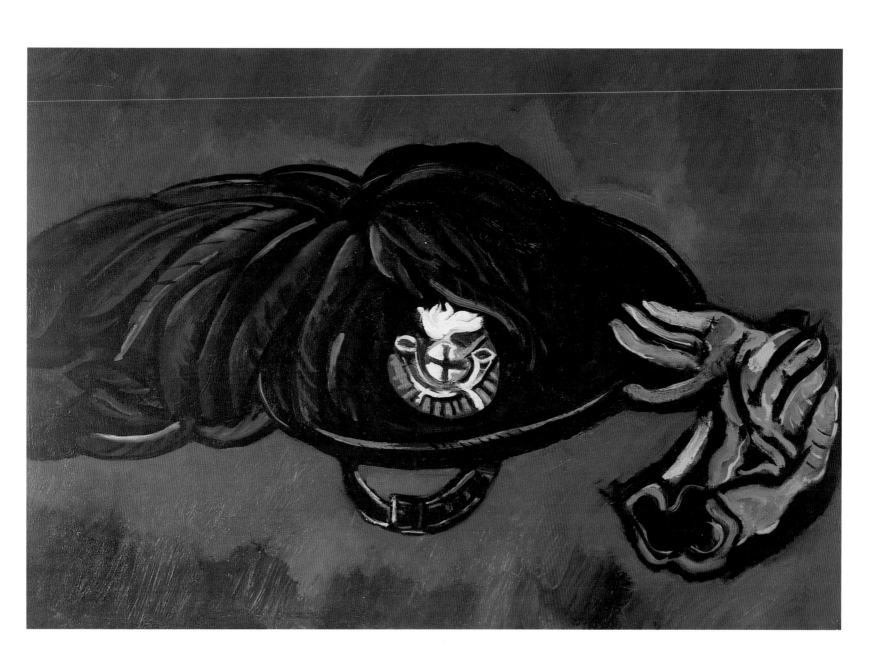

23

SMELT BROOK FALLS, 1937

IN an introduction Hartley wrote for an exhibition at An American Place in the spring of 1937—the last show he did with Stieglitz—he declared that he wished to be known as "the painter from Maine." He set about accomplishing that with a will, and for much of the summer he lived with Madame Gaston Lachaise in Georgetown, Maine. He spent ten days on the island of Vinalhaven, off the Maine coast, deciding that he would reside there the next summer. Although by the end of that summer in typical fashion he dismissed the people in Georgetown as "a dull lot—mostly Boston suburbanites—and I think the name Dedham changed to Dead'em would cover them all," he had done some fine painting and knew it. He told Adelaide Kuntz that "it has been such a joy to come home to my native heath & feel so content here & now I am completely in the thing." For that moment he was confident that "these are my big years…. Life not only begins but doubles at 60—and such an onrush of fresh energy fairly surrounds me."

It is a mark of Hartley's talent that he could seize upon an artistic idea and make it work for him. He recognized that the Regionalists—painters such as Thomas Hart Benton, Grant Wood, John Steuart Curry, and many of the artists supported by the Public Works of Art Project—were receiving wide attention, and he wanted to benefit from it. If the public wanted American subjects, he would "ram that idea down their throat till it chokes them even," he had told Adelaide Kuntz in 1936. Despite such bitterness, after his grief over the deaths of the Masons subsided, he took on Maine with immediate success. Paintings such as *Smelt Brook Falls* and *End of Storm, Vinalhaven, Maine* are superb examples of his mastery of Maine land and seascapes. Both show his

(continued on page 72)

Oil on board, 28 x 22 inches, the Saint Louis Art Museum, purchase, Eliza McMillan Fund

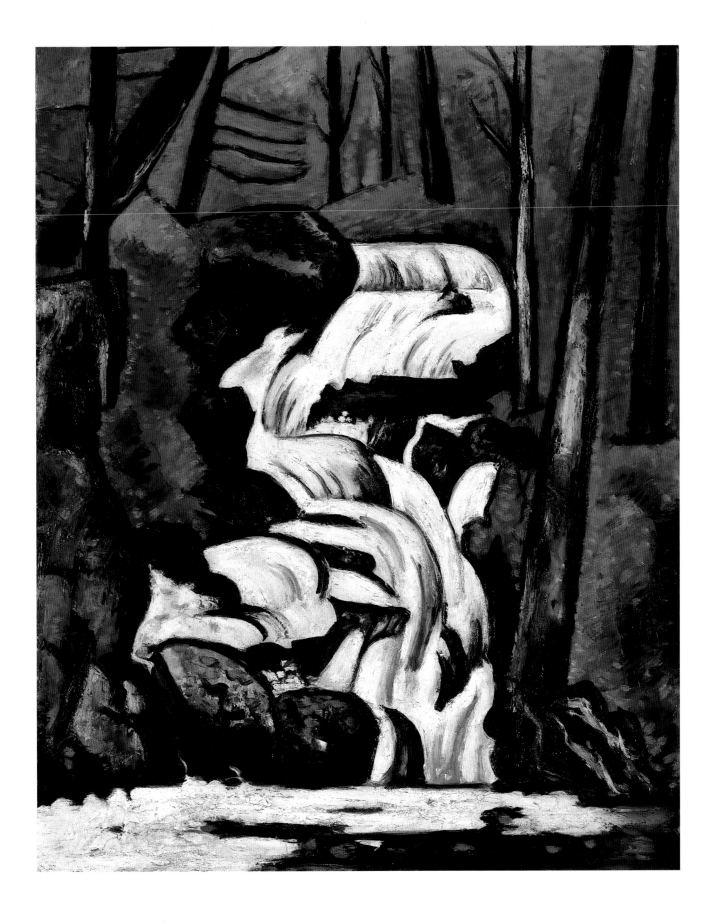

(continued)

continued awareness of Cubism and also his Cézannesque insistence upon rendering elemental forms, but the two are significantly different in the degree to which Hartley flattened out his subject matter as he had done with his paintings of the Alps. *Smelt Brook Falls* is monumental and nearly two-dimensional; *End of Storm, Vinalhaven, Maine,* while also monumental, has depth because the coast and the offshore islands were his subject matter, part of what in his introduction to the American Place show he had termed a "strong, simple, stately, and perhaps brutal country." The rocks in the immediate foreground, the waves and foam behind them, the small but rugged cliff next, and even the bank of trees behind it are flattened out and delineated by dark lines so as to convey a sense of nature's power. The space and distance of the background—islands on the horizon and above them a looming white cloud—suggest what is far off, the spiritual, which exists beyond the harshly immediate foreground. "I have a whole row of forceful sea pieces," he wrote Adelaide Kuntz in November as he was about to leave Georgetown. Two were "crashing seas on the rocks and I am delighted with myself to come so near to the real thing—and so alive and spontaneous."

Oil on academy board, 30 x 40 inches, collection of Barbara B. Millhouse, photography by Jackson Smith

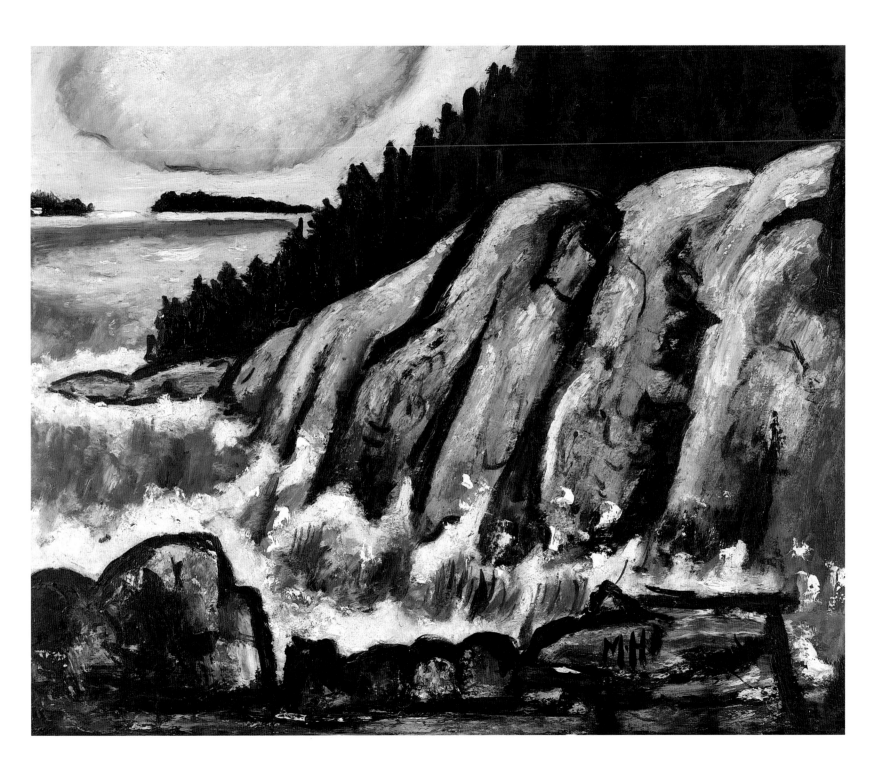

25
THE LIFEGUARD, c. 1940

IN 1938 Hartley began memory portraits of the Masons and of his artist hero Albert Pinkham Ryder, and in the next years did others, as well as figurative paintings such as *The Lifeguard*. His interest in the human figure signaled a newfound concern for community and a willingness to express his admiration for the male body. Cooped up in any small Maine village for long, he would soon want a trip to some place like Old Orchard Beach in southern Maine, where he might "enjoy so lovely a spectacle as that five mile beach covered with handsome humanity." "In the Masons," Gail Scott has noted, Hartley "had found the exact measure of mystic humanism to inspire a whole series of figure paintings in his final years." The archaic figures become icons, plain folk who "defined for him the true meaning of strength, sacrifice, hardship, and virtue," Scott pointed out. "They made it possible for him to deal overtly with the spiritual dimension."

The Lifeguard is a heraldic painting, by no means realistic, which celebrates the young men Hartley observed at Old Orchard Beach, who reminded him of the Masons. The upright hair of the central figure, while blonde (and somewhat like a halo), is similar to Alty Mason's, as is that of the man on the right with his back turned to us. The three figures over whom the lifeguard towers can represent Alty, Donny, and their cousin. While the lifeguard—a blend of strength, human courage, and male sexuality—stands over them and offers what protection he can, the other three men have their backs to him and stare out at a rough, scarcely delineated ocean that blends with an infinite sky. Hartley obviously did not care about exact realism; the horizon is canted. Remove the four archaic figures, and the strong colors of the beach, the ocean, and the cloud-filled sky have approximately the effect of Mark Rothko's later color abstractions.

The painting becomes a statement about community, man's earthbound nature, and his quest for the infinite. The powerful lifeguard stands between us and the ocean, but Hartley understood that ultimately he could not save humans if, like the Mason sons and their cousin, they cast off from land.

Oil on board, 28 1/2 x 22 inches, courtesy Hirschl & Adler Galleries

74

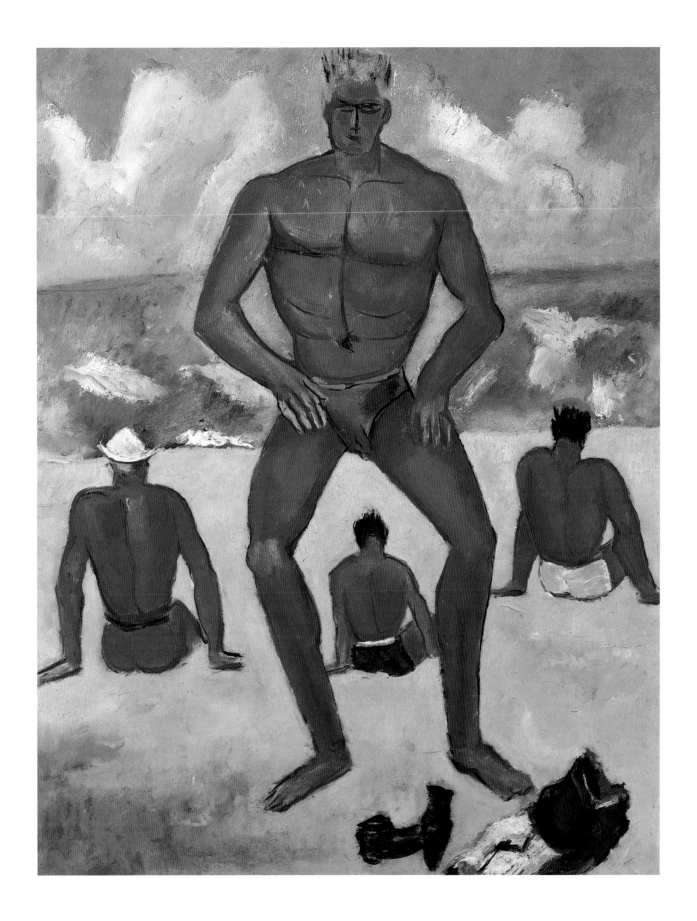

26
MT. KATAHDIN, 1941

IN September 1939 Hartley moved to Bangor, Maine, where he intended to stay during the fall so that, among other projects, he could paint Mount Katahdin, the state's highest mountain and one that stood out impressively—like Mont Sainte-Victoire. By mid-October he met Caleb Scribner, the chief fish and game warden for the district. Scribner drove the both of them to a site in Baxter State Park, where they hiked four miles into a wilderness camp on the edge of Katahdin Lake. Hartley remained at the camp, where he studied the mountain and made his first sketches and preliminary paintings of it. Six of the eight days he stayed at the camp were clear; that, coupled with his admiration for Scribner, the pleasure of meeting Bud and Della Cobb, who ran the camp, and his exhilaration at making the strenuous hike in and out of it, filled him with new energy. "My work is getting stronger & stronger and more intense all the time which is most heartening at 63," he wrote Adelaide Kuntz in February 1940. By then he had already finished six paintings of Katahdin; three years later, when he finished the series, he had nearly twenty.

None of the paintings are literal—among other things he moved Baxter Peak, the highest part of the mountain, to the center of his landscapes and brought it much closer into the foreground than it was from where he sketched it at the Cobb's camp. Also, he simplified his colors down to two or three in each painting so that the viewer's eye remains centered on the mountain, not at all on the rest of the landscape.

After his adventure he wrote a poem, which ends:

> The moment of a man clawing at a cliff
> is nothing to a cliff.
> It is the man that bursts with enmity
> toward something bigger than himself—
> the whisper of a mountain floors him
> suspending his ankles to a laughing
> wind.

"I know I have seen God now," he wrote his friend Elizabeth Sparhawk Jones in October once back in Bangor. "The occult connection that is established when one loves nature was complete—and so I felt transported to a visible fourth dimension—and since heaven is inviolably a state of mind I have been there these past ten days."

Oil on masonite, 22 x 28 inches, Schrag Family Collection

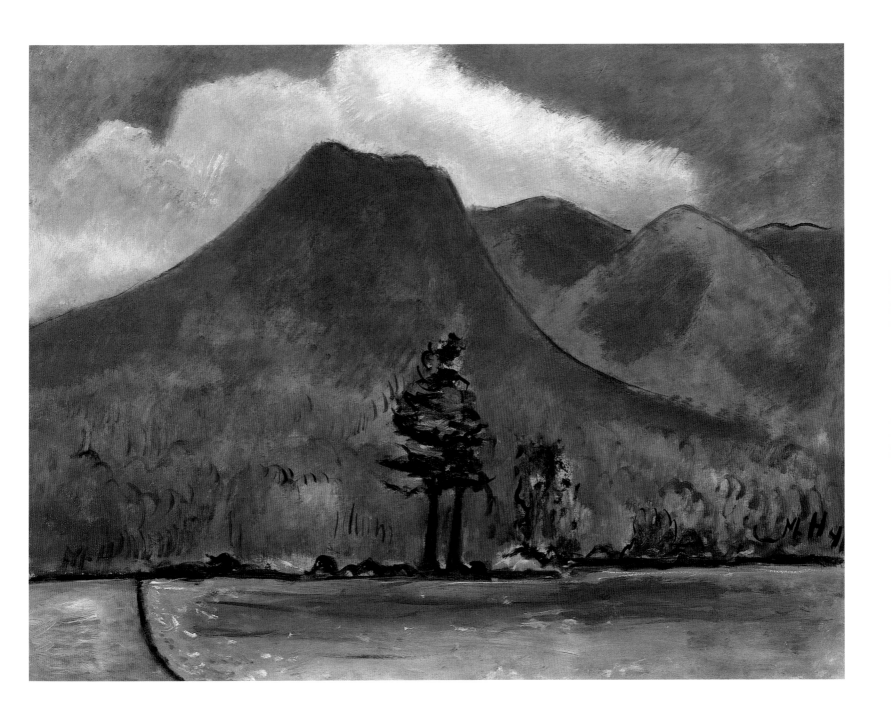

27
SHELLS BY THE SEA, c. 1941–43

IN 1939 the painter Waldo Pierce drove Hartley along the coast of Maine as far east as the fishing village of Corea, forty miles beyond Ellsworth. "Pretty name—and God! was it a beauty," he wrote Adelaide Kuntz after his visit, and he described it to another friend as a "wonderful fishing village, a real one, and so like my beloved Nova Scotia, dear old boys sitting in their fish house doorways, quantities of lobster-pots lying around, a P.O. and grocery, and a fish-shop." The last four summers of his life he stayed in Corea, painting as copiously as ever, although ill health slowed him and he was sometimes confined to working in the chicken coop that had been converted into a studio behind the house where he lived.

In the little studio he painted still lifes such as *Shells by the Sea*, reminiscent of the work he had done earlier but, if anything, more powerful because more direct and spare. *Shells by the Sea* is an excellent example of what Gail Scott has written about Hartley's last work, that it is "the painting of essential reality, in which what is left unsaid, the profoundly empty space behind the image, conveys as much as the actual object. Suspended in this Zen-like emptiness are small mundane objects...depicted with a deceptively simple—even, at times, ungainly—directness." These shells are hardly ungainly, but set as they are against a dark, mottled background, they are absolutely direct, and the painting becomes a blending of the abstract and the real. Painted late in life, *Shells by the Sea* was precisely what Hartley had come to understand as the essence of spirituality.

Oil on masonite, 28 x 22 inches, courtesy Babcock Galleries, New York

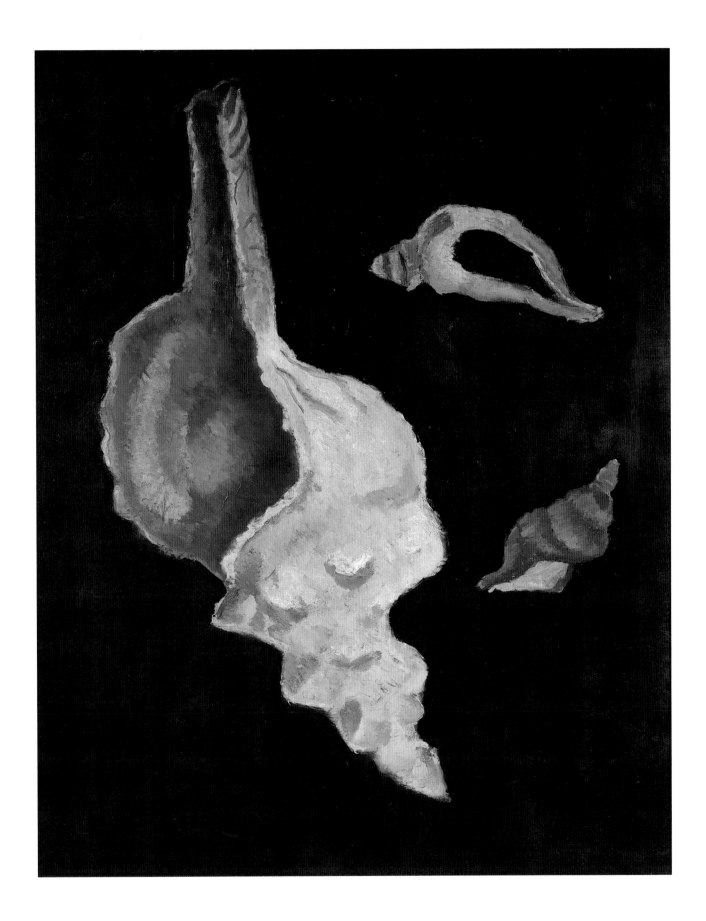

SELECTED BIBLIOGRAPHY

"American Artist Astounds Germans." *New York Times* (19 Dec. 1915): 4.

Burlingame, Robert Northcutt. "Marsden Hartley: A Study of His Life and Creative Achievement." Ph.D. diss., Brown University, 1953.

Eldredge, Charles C. "Nature Symbolized: American Painting from Ryder to Hartley." In *The Spiritual in Art: Abstract Painting, 1890-1985.* Los Angeles: Los Angeles County Museum of Art; New York: Abbeville Press, 1986.

Ferguson, Gerald, ed. *Marsden Hartley and Nova Scotia.* Halifax: Mount Saint Vincent University Art Gallery, 1987.

Gaetgens, Thomas W. "Paris-Munchen-Berlin. Marsden Hartley und die europaische Avantgarde." In *Kunst um 1800 und die Folgen.* Munich: Prestel Verlag, 1988.

Gallup, Donald. "The Weaving of a Pattern: Marsden Hartley and Gertrude Stein." *Magazine of Art* 41, no. 7 (Nov. 1948): 256-261.

Hartley, Marsden. "Aesthetic Sincerity." *El Palacio.* Santa Fe, NM (9 Dec. 1918): 332-333.

_____. "America and Landscape." *El Palacio.* Santa Fe, NM (21 Dec. 1918): 340-342.

_____. *Adventures in the Arts: Informal Chapters on Painters, Vaudeville and Poets.* New York: Boni and Liveright, 1921.

_____. *On Art.* Gail R. Scott, ed. New York: Horizon Press, 1982.

_____. *The Collected Poems of Marsden Hartley, 1904-1943.* Gail R. Scott, ed. Santa Rosa, CA: Black Sparrow Press, 1987.

_____. *Somehow a Past: The Autobiography of Marsden Hartley.* Susan Ryan, ed. Cambridge, MA: MIT Press, 1997.

Haskell, Barbara. *Marsden Hartley.* New York: Whitney Museum of American Art and New York University Press, 1980.

Hokin, Jeanne. *Pinnacles & Pyramids: The Art of Marsden Hartley.* Albuquerque: University of New Mexico Press, 1993.

King, Lyndel. *Marsden Hartley, 1908-1942: The Ione and Hudson D. Walker Collection.* Minneapolis: University Art Museum, University of Minnesota, 1984.

Levin, Gail. *Synchronism and American Color Abstraction, 1910-1925.* New York: George Braziller, 1978.

_____. "Marsden Hartley and the European Avant-Garde." *Arts Magazine* (Sept. 1979): 158-163.

Lowe, Sue Davidson. *Stieglitz: A Memoir/Biography.* New York: Farrar, Straus and Giroux, 1983.

Ludington, Townsend. *Marsden Hartley: The Biography of an American Artist.* Boston: Little, Brown, 1992.

Lynch, Michael. "A Gay World After All." *Our Image: The Body Politic Review Supplement* (Dec.-Jan. 1976-77): 1-3.

McCausland, Elizabeth. *Marsden Hartley.* Minneapolis: University of Minnesota Press, 1952.

McDonnell, Patricia. "Spirituality in the Art of Marsden Hartley and Wassily Kandinsky, 1910-1915." *Archives of American Art Journal* 29, nos. 1 and 2 (1989): 27-33.

_____. "El Dorado: Marsden Hartley in Imperial Berlin." In *Dictated by Life: Marsden Hartley's German Paintings and Robert Indiana's Hartley Elegies.* Minneapolis: Frederick R. Weisman Art Museum, University of Minnesota, 1995, 15-42.

_____. *Marsden Hartley: American Modern.* Seattle: The University of Washington Press, 1997.

Robertson, Bruce. *Marsden Hartley.* New York: Harry N. Abrams with the National Museum of American Art, Smithsonian Institution, 1995.

Scott, Gail R. "Marsden Hartley at Dogtown Common." *Arts Magazine* 54, no. 2 (Oct. 1979): 159-165.

_____. *Marsden Hartley: Visionary of Maine.* Presque Isle, Maine: University of Maine, 1982.

_____. *Marsden Hartley.* New York: Abbeville Press, 1988.

Udall, Sharyn. "Marsden Hartley." In *Modernist Painting in New Mexico, 1913-1935.* Albuquerque: University of New Mexico Press, 1984, 29-52.

Weinberg, Jonathan. *Speaking for Vice: Homosexuality in the Art of Charles Demuth, Marsden Hartley, and the First American Avant-Garde.* New Haven: Yale University Press, 1993.